GOING DIGITAL

GOING DIGITAL

SIMPLE TOOLS AND TECHNIQUES
FOR SHARING AND ENJOYING
YOUR DIGITAL PHOTOS AND HOME MOVIES

Alex L. Goldfayn
The Technology Tailor

Collins
An Imprint of HarperCollinsPublishers

HarperCollins books may be purchased for educational, business, or
sales promotional use. For information please write: Special Markets
Department, HarperCollins Publishers, 10 East 53rd Street, New
York, NY 10022.

FIRST EDITION

Designed by Simon M. Sullivan

Library of Congress Cataloging-in-Publication Data has been applied
for.

ISBN-10: 0-06-087318-3
ISBN-13: 978-0-06-087318-9

06 07 08 09 10 RRD/WBC 10 9 8 7 6 5 4 3 2 1

To my family, with love.

CONTENTS

A LETTER FROM THE AUTHOR

Dear Reader,

I believe this little book will change your life. And if you give me the next five minutes—the time it will take you to read this brief letter—I'll tell you how. And why.

The thing is, you've been through a lot. I've been covering technology for newspapers, magazines, and television news programs for many years, and I know how difficult it is to keep up with all the new high-tech products that are fired at you by the technology industry. It seems like every day—heck, every hour—there's a new product released that's better, faster, cooler, sexier, bigger (smaller), flatter (wider), more metallic, less blue, and so on, than the one that came before it, or, worse, the one you invested in not long ago.

Which one should you buy? What's worth your hard-earned money? And why, oh why, does the technology industry insist on talking about their tools in a foreign language? We always hear about megabytes and megahertz and megapixels (oh my!), but we almost never hear about the real, meaningful, life-improving ways in which we can use this new technology. Whether it's in ads or in your local newspaper's product reviews, everybody wants to regurgitate technical specifications. But nobody talks about what a particular technology can *do for you*.

And with cameras and photography, this has been especially true, and particularly painful. You see, until very recently (the last five years or so), photography had not really changed. We took pictures with 35-millimeter cameras, we captured them to film, and we got them developed into prints at the store. That had been

the process for 50 years or more. Then, suddenly, dramatically, digital photography came along and turned that process upside down.

With digital, the cameras still look the same, but there are hundreds of them to choose from: big ones, little ones, itsy-bitsy ones, and even ones on your cell phone. No more film: The pictures are stored on memory cards. And all kinds of weird language is used to describe these digital cameras: megapixels, digital zoom, optical zoom, USB and FireWire, xD, SD, CF, and MemoryStick PRO Duo, which is different from the MemoryStick PRO (duh!).

All of this is a big problem because it has to do with our photographs, the memories of our lives. Think about the first thing most people say they would pull out of their home if it was on fire. Even a sitting president has talked about it.

When George W. Bush was touring Southern California after it was severely damaged by wildfires, he met with reporters and recounted a conversation he had with a woman who lost her home. The first thing he told the journalists was how horrible he felt that she lost all her photographs in the fire. Her pictures, he said simply, were gone.

In the New Orleans, after Hurricane Katrina ripped through and after the floodwaters rose, many attempted to return to their homes for their family photos. When all else was lost, many counted their photos, wrapped in plastic bags, among their last possessions.

Our photographs make up the memories of our lives; they are among the most emotional, meaningful, and significant things we have. And when we're gone, our photographs become the legacies of our lives. They're the history we leave behind for our children, their children, and everyone who comes after us.

All of which is exactly opposite of the impersonal, cold way that digital cameras are presented to us. The impossible-to-

remember model numbers, the sheer volume of models, and the high-tech specifications that are used to describe digital cameras don't exactly put us at ease about making the switch from film photography to digital.

But that's only the beginning.

Everywhere I go—whether at dinner parties or after giving speeches or television news interviews—people ask me the same question: "What can I do with the photographs?" With film, we knew what to do. With digital, many people don't even know how to get the photos from their camera to their computer.

Many people still don't know that you can make super high quality prints from your digital photos at your local drugstore or camera store today. And if they do know that, they probably don't know *how* to do it. We don't know because nobody has taught us. We're relying on the technology industry—which has a hard time creating a readable user manual—to teach us how to get the most out of our photographs.

Further, you probably don't know how to enjoy your photos in your living room, on television, playing to the music of your choice. This can be done right from your computer, or through a DVD complete with professional-looking menus. It's no surprise that you don't know how to do this; nobody has taught you how.

Also, if you're converting to digital photography, what's to become of your old nondigital photos? From now on, will there always be two categories of family photos? The ones in albums and the ones on your computer? Of course not. But nobody has taught you how to combine them.

And what of your home movies? The ones from your life, and your children's lives? Can they be edited (yes), narrated (yes again), and set to music (of course)? Can you combine old movies with old pictures on a cool DVD that you can share with family and friends? Most definitely.

In this book, I will teach you how. In simple, easy-to-understand, nontechnical language, I will teach you how to do all of the above. You've had enough tech-speak, and, frankly, so have I. It's time to talk about all of the fabulous things you can do with your digital photographs and home movies in simple English.

This little book will arm you with the tools and techniques you need to share your digital memories with friends and family online and offline, on the computer and in the living room. It will give you a world of wonderful possibilities for your photographs and home movies—your family memories, your history, your legacy. Which means that what you're about to read will affect not only your own life but also the lives of your children and grandchildren, your family and friends.

Respectfully,
Alex L. Goldfayn

INTRODUCTION

We crowded around the photos with our family less than an hour after we had returned from a two-week vacation in France. There were about 850 shots, organized by city.

Our family marveled and laughed with my wife and me as we told them the stories behind the beautiful images from Paris, Nice, Cannes, Entrevoux, and Monte Carlo. There were photos of the prerequisite sights, the entertainment, and, yes, the fabulous food. (Our camera takes stunning up-close portraits of dishes.)

The author, in Paris

How were the photos developed so quickly?

They weren't.

You see, we weren't looking at them in a photo album. Or as printed snapshots. Rather, they were being displayed on our television—in 52-inch big-screen glory—as a digital photo slide show. The slide show played on a laptop, which was connected to the TV with a simple yellow component video cable.

Over the next few days, I reviewed the photos on my computer, cropped them to remove unwanted parts of the pictures, slightly adjusted the colors, turned a few into black-and-white shots, and narrowed the complete set down to about 300 of the best photographs. I copied them onto a CD-ROM which I brought to my

corner Walgreens—but it could have been Wolf Camera, Wal-Mart, or my local independent one-hour photo shop. I popped the disc into the electronic kiosk and went through the prompts. I wanted one 4 × 6–inch print of each image on the disk. In an hour, my glossy snapshots were ready—produced by a high-end Fuji photo printer, the same one Walgreens uses to print photos from 35-millimeter film.

The cost? Nineteen cents per print at the time (I used a coupon from my Sunday newspaper), or about $65 with tax for 300 of our very best, computer-enhanced photos. That's equal to about 13 rolls of 24-exposure film, at less than $5 per roll. But remember, we started with 850 shots. I picked the best ones, enhanced them, then printed them—a process that's impossible with film but costs about the same as developing film.

How did the photos look?

Spectacular.

Better than anything we've ever developed from film, which is predominantly a result of our high-end camera, not the printing at Walgreens. The colors leapt off the paper. In our hands, they felt exactly like photos developed from film. That's because these photos were printed on the same paper, using the same chemistry as film photos. All this made my wife very happy, and she went to work on a photo album with the prints.

Satisfied but aware I had not yet hit the digital photography home run, I returned to the computer to create a DVD slide show, complete with professional-looking menus and background music. I categorized and subcategorized the photos into folders (think Paris sights, cuisine, and nightlife) and selected music from our computer's MP3 library that matched. Then, on the basis of my categories, the DVD program built the menu structure.

The whole process took parts of one weekend, but the end re-sult was a fabulous gift to our family. They received DVDs, com-plete with opening scenes, menus, and all 850 photos, which

played as a slide show set to music. Our family can run the show on their TV in automatic mode—which I had set to switch the photos every three seconds—or use their DVD player's remote control to move through the shots. Each DVD also had the complete set of image files, which our recipients could copy onto their computers for editing, printing, and/or sharing.

EVERYTHING HAS CHANGED

And then, watching our parents watch the DVD as though they were lost in a great movie, it hit me.

Everything has changed. And people need to know.

You see, after a century of film-based photography, digital photography and video have fundamentally changed the way we capture, share, and store our memories—and it has all happened in the last few years. And even though some people know about some of the possibilities, this new technology has come upon us so quickly that most people are simply scratching the surface of possibility—which, I've discovered, is only limited by your imagination. In fact, for many digital camera users, the computer has replaced shoeboxes full of photographs in the closet. Sure, you've probably e-mailed some of your photos to friends and family and printed some of them at home. But mostly, the digital photos just sit there on your computer, if they even get there in the first place.

There's so much you can do with them—and that's what this book is about. You will learn all of the magnificent things that you can do with your digital photographs and home movies. With the combination of your digital camera, camcorder, your computer, and the Internet, you too will be able to watch slide shows on televisions and pass out DVDs filled with fabulous photos, set to the music of your choice and with professional-looking menus, to your friends and family.

IRREPLACEABLE FAMILY MEMORIES, COLD TECHNOLOGY

For most people, there is no physical thing more valuable or significant than their photos and home videos. So you would simply assume that the technology industry would approach selling and marketing their photographic and home movie products in a manner that's consistent with our emotional attachment to our family photos and movies. But as you probably know from experience, that assumption would be incorrect.

Like computers, digital cameras are sold through a listing of highly technical, completely boring, and difficult-to-understand specifications. So are photo printers, scanners, digital video cameras, and nearly every piece of technology that has to do with going digital in the film photography and video world.

When buying a digital camera, you may hear this inspiring recital from the salesperson: "This is a five-megapixel pro-sumer model with a 20× zoom, but only 2× is optical and 10× is digital. There's a 1.8-inch LCD, but it's usable for review only. It can also display histograms. There's a fifty-dollar rebate today, so the camera costs only five hundred dollars. You'll need a 512-megabyte compact-flash memory card too. Those are only one hundred twenty dollars. Oh, would you like to purchase our seventeen-year service plan with this? We don't make a commission on those. Really."

Makes you want to open up your wallet, doesn't it?

THE TECHNOLOGY TAILOR'S APPROACH TO GOING DIGITAL

The salesperson has told you nothing about what's really important: Does it take good photographs? What else does it do? (Many cameras now capture video and connect directly to printers with-

out a computer, and some even log on to the Internet.) How many pictures can be stored on the memory card being recommended? And how easy is it to transfer photos from this camera to a computer?

That's what is relevant. After all, this digital camera—or digital camcorder or photo printer or scanner—is for capturing, sharing, and enjoying the moments of your life. This technology will forever memorialize your vacations; birthday parties; weddings; family dinners; Christmas mornings; your grandchild's first steps, first ballet recital, and a thousand other firsts; the funny things your dog, cat, or goldfish does; and every other priceless memory you wish to crystallize with a photograph or home movie. That's the magic of *Going Digital*. It's about you. It's about your life and preserving your most precious moments.

My approach to going digital has little to do with the cold, boring technical specifications of technology and everything to do with how to apply this fabulous technology to your life in meaningful, practical ways. It's about tailoring the technology to your unique, specific needs, just as a fine suit is tailored to the unique shape of your body. Unfortunately, the technology industry itself offers precious little tailoring, or even explanations of how to apply their products to your own objectives. Fortunately, however, *Going Digital* will teach you the fabulous ways that digital photography and home movies can be integrated into your life.

WHAT YOU'LL LEARN IN *GOING DIGITAL*

And here's the best part: It's easy to go digital, and you probably already own much of the technology you'll need. (I believe in getting the most out of the technology you already own, not in purchasing as much technology as possible.) Here's what else you'll learn:

· **The big-picture potential of** *Going Digital:* In nontechnical language, with lots of real-life stories and examples from my own experience and the experience of the thousands of people who have told me their technology stories for my columns, news articles, and television and radio appearances and speeches, I'll lay out the amazing, easy ways that you can use today's (and even yesterday's) technology to capture, store, share, and enjoy your memories with friends and family.

· **The technology tools that make up a digital toolbox:** I'll lay out the hardware and software that can now be used to print, share, and enjoy your digital photos and home movies. And I repeat: You probably own some of the technology required for this. (For example, you have a television, don't you?)

· **How to shop for and find the best prices on the best technology for you:** You'll know where to go (online and offline) to find coupons, discounts, and rebates on every kind of digital technology. I'll also teach you what questions to ask when shopping for this technology.

· **How to print digital photographs that look and feel like the prints you get from film:** You can now make fabulous prints at home, at retail locations, and by ordering them online.

· **Eye-opening ways to share your digital memories with your friends and family:** You'll know how to put your photos and home movies on DVDs to enjoy with your family in the living room. And I'll teach you how to use an Internet-enabled photo frame that displays a slide show in any home with a telephone line. This is a great way to share photos with family members without a computer.

· **Fabulous digital projects like how to make and send greeting cards with your own photos without ever licking an enve-**

lope: I'll show you how to combine digital photographs with your family tree, and we'll discuss scrapbooking in the digital age.

· **All about camera phones:** What can you do with the photos that you take with your wireless phone? I'll tell you about Web sites and tools that are specifically designed to help you share your cam-phone photos.

· **The resources you'll need to stay current on this subject:** What are the best places to read about new technology that's coming out? Where can you find reviews of products not only from experts but also from consumers just like you?

Going Digital will teach the magnificent ways that you can capture, store, print, share, and enjoy your photographic and movie memories with your family and friends. As such, it will change not only *your* life but also the lives of your family and friends.

CHAPTER I
THE WONDERFUL WORLD OF DIGITAL

WHAT IS GOING DIGITAL?

Going digital is . . .

Eighty-one-year-old John sending his extended family simple, annotated photo albums of family events and family history on CD. Recently, John sent 50 family members digital photo albums of his fiftieth wedding anniversary party.

Anthony videotaping his baby son's first steps, first words, and first climb across the monkey bars; editing those movies on his computer; and sharing them on a simple-to-make Web site with family and friends.

Andy creating a slide-show tribute DVD to his uncle for his seventieth birthday party. The 20-minute show featured photographs from his uncle's life and video of his past haunts and hangouts, all set to music and shown on a big-screen projector to a tearful gathering of family and friends.

Stephan digitizing movies from his mother's life, editing them, and creating professional-looking DVDs—complete with menus and behind-the-scenes "making of" footage—on his computer. Even old-style reel-to-reel films from the first half of twentieth century were included.

My wife, Lisa, creating a most amazing memory book for her father, Ron, on his sixtieth birthday. The book included hundreds of photos from his life—some scanned from film, slides, and dusty old dog-eared pictures, others taken with digital cameras. It was done scrapbook-style, with written memories—e-mailed in by family and friends—interspersed with the photos. Of course, my father-in-law loved his gift, and, testing the patience of those around him, happily narrated every photo in the book as he flipped through its pages for the first time.

Stephanie taking pictures with her cell phone and sending them, with recorded voice explanations or questions ("What do you think of this outfit?") to her family and friends. She shares some of her favorites on a Web site designed especially for pictures taken with camera phones.

So what is going digital?

It's a whole new way to capture, share, organize, and enjoy your most precious possession: the memories of your life. It's using common, affordable (sometimes free) technology to bring your photographs and home movies to life.

That is going digital.

SOME HOUSEKEEPING

THE MEMORIES OF YOUR LIFE— THE STORIES OF YOUR PEERS

I've found that people learn best through the experiences of their peers. Although you're used to experts talking at you, you'll be able to relate better to the stories of real people, some of whom are in a personal and professional place in life similar to yours.

It's my goal to motivate you to action with these people's stories. As you read through the amazing things people are doing with their digital pictures and home movies, I hope you will think, *This isn't so hard. I can do this too.* In most cases, you will already have most of the technology you will need. You will be either a free download or a very small purchase (usually less than $50, and what's 50 bucks if it brings your loved ones joy and happiness?) away from taking advantage of some of the techniques presented here.

Throughout this book, I'll balance my own advice with the stories of the people introduced briefly above and of others. All of them have found their own unique way to go digital. Between my

experience and their stories, you'll be able to select the tools and techniques that will bring the stories of *your* life to life.

THE WORST THING YOU CAN DO IS EVERYTHING

The pages of this book are filled with tools and techniques for sharing and enjoying your photos and home movies. From experience, I know that if you try to use all, or even most, of the ideas right away, you'll be frustrated and overwhelmed, and you'll probably return your photos and movies to their original resting place: a dark spot, far from view. The doing-everything-all-at-once-is-overwhelming principle is especially true when it comes to technology, where things are usually awkward and strange at first.

And since we're dealing with the precious memories of your life, it's important to pick the right tools for you, and, critically, begin with only one or two new tools or processes. Try them, get comfortable with them, see if you like them, and then move on to some others.

Which brings me to this: this may not be a book you'll read from beginning to end. You may, for example, be most interested in learning how to make great-looking prints of the digital photos being stored on your computer. If so, jump ahead to chapter 4 now. Or you may have recently bought a cell phone that takes pictures, and you want to know what you can do with them. If this is the case, move up to chapter 7. Or you may never read the chapter on camera phones because it isn't relevant to you. The point is, feel free to jump around and go through the chapters that interest you most.

The tools and techniques for getting the most out of your photos and home videos are waiting for you in this book as you need them, when you need them. Use them at your convenience.

ALL OR NOTHING IT'S NOT

One of my basic principles about applying technology to your life in meaningful ways is that it's not an all-or-nothing proposition. In other words—and this is a surprise to many people who read my work and hear my speeches—I don't suggest you substitute the nontechnical methods that you're currently using with high-tech, digital-age, Silicon Valley–made tools.

For most people, going digital automatically starts with a digital camera. In fact, as you read this, about 60 percent of all Americans own one. But a digital camera is not a requirement for making digital photographs. If you want to, you can easily and affordably keep using your favorite film-based camera, develop photos at your local drugstore or camera store, and scan them into your computer. (I'll cover scanning in more detail in chapter 2). And voilà! You have digital photos. While some may argue that this defeats the natural ease and convenience of digital photography, I disagree: Going digital should be about what's comfortable and convenient for you. If you love your film camera, yet want to enjoy the great advantages of digital photos, buy a good scanner for about $150; *that* is your "digital balance." *There's no specific formula for doing this—it's about what works for you.*

So if going digital doesn't necessarily start with a digital camera, where does it begin? I think it starts with the digital *photos*. The photos (and your digitized home movies) make up the ingredients of the digital recipes (projects) we'll discuss throughout this book.

DEFINING *DIGITAL*

As a rule of thumb, think of digital photos and movies as those that can be *computerized*. If you can load them onto your computer, for manipulation, printing, editing, and deleting, they're

digital. What about your nondigital paper photos? If you scan them into your computer (and I'll get into scanning details in the next chapter), you make them digital.

So basically, digital photographs and movies equals computerized photos and movies. Easy, no?

WHAT'S THE DIFFERENCE BETWEEN FILM-BASED AND DIGITAL PHOTOS?

You can do only one thing with film-based photos: get them developed. You can't really edit them, you can't set them to music, and you certainly can't watch them on television. It's really difficult to make greeting cards from them and far more difficult to share them with your family and friends. What a pain it is to identify the snapshots your loved ones want reprinted, track down the minuscule negative number, and drag everything to your local photo developer for reprinting.

Of course, with digital photos, you can do all these neat things that film can't handle. Slide shows? No problem. Send prints to Mom and Dad? Simple. They can see them digitally via e-mail or your favorite photo-sharing site, or you can have prints sent directly to their mailbox. You can even send your latest snapshots to a digital photo frame at Mom and Dad's house, which displays them electronically, as a slide show, on a framed LCD screen—no PC required. Adjust and edit your photos, crop them, and delete the ones you don't want? It's done in a few seconds. (I'll take you through all of these processes in upcoming chapters.)

With film, you get what you shoot. And you don't know what you have until you pick up your developed shots at the store. You may make use of only half of the photos that were developed, but you pay for all of them.

With digital, you take a picture and you see it immediately. If you don't like it, press the Delete button and it's gone. Or keep it and see if you can improve it after it's transferred to your computer.

With film, you pay for every roll that is fed through your camera. When the photos are developed, you get the negatives, and it's time to buy more film. With digital, you pay for a memory card once and use it over and over. When it's filled with pictures, just transfer them to your computer or go to your local digital photo retailer get your photos transferred to a CD-ROM; this process costs less than $5 and is one of the reasons you *do not even need a computer* to enjoy digital photography. I know many people who own a digital camera but don't use it with a PC.

Similarly, with film, you're limited to the number of photographs available on your roll. Once it's filled, you need to put in another roll. With digital, even if your memory card is full, you can free up space by deleting some of your least-favorite photos *right on the camera*! Then you can shoot away again.

Overall, especially with the cost of today's digital cameras on par with similarly functioning film cameras, going digital is much cheaper in the long run than staying film. Also, it's more flexible, it's more immediate, and you can do far more with the photos once you have them. That's what much of this book is all about.

WHERE DO DIGITAL PHOTOS COME FROM?

Below is the *Going Digital* process for photographs. As you can see, it starts with the digital photos, not the digital camera. There is a wide range of ways to create digital photos. Here is an overview of each possible source of digital photographs (with details and specific resources to come later):

GOING DIGITAL WITH PHOTOS

*(Or, things to do with your photos that
will make your family really, really happy)*

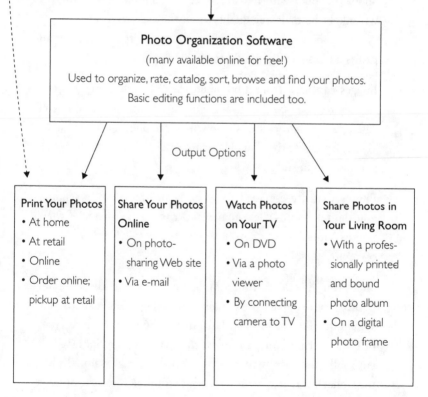

Your Digital Photos

- From digital camera
- From scans of photos/film
- From your camera phone
- Taken from your digitized home movies
- Photos of family/friends from the Web
- Photos that are e-mailed to you

imported into

Photo Organization Software

(many available online for free!)
Used to organize, rate, catalog, sort, browse and find your photos.
Basic editing functions are included too.

Output Options

Print Your Photos
- At home
- At retail
- Online
- Order online; pickup at retail

Share Your Photos Online
- On photo-sharing Web site
- Via e-mail

Watch Photos on Your TV
- On DVD
- Via a photo viewer
- By connecting camera to TV

Share Photos in Your Living Room
- With a professionally printed and bound photo album
- On a digital photo frame

- **Digital camera snapshots:** These are the most straightforward of all. Point your digital camera, take some pictures, and you've got digital photos. These images, more than anything else, are the building blocks of going digital.

- **Photos you scan:** A good photo scanner can be purchased for about $150. Connect it to your computer and those old, dusty photographs of your parents and grandparents can quickly and easily be digitized for inclusion in photo albums, DVD slide shows, and sharing online. You can make scans from photographic prints, 35-millimeter film, and slides.

- **Shots you take with a wireless camera phone:** These images will likely be of lower quality than the ones you take with a "real" camera, but they're still quite usable for making small prints and especially for sharing online.

- **Images captured from a home movie:** When you import your movies to your computer for editing and manipulation, you can actually capture still shots, which are photographs of individual frames of the film. These are often great to share online and include in slide shows.

- **Photos that are e-mailed to you:** Friends and family sending you digital photos via e-mail? You can use as many of their photos, unless they carry a copyright, as you want for your own purposes.

- **Shots you download from a Web site:** You know those digital photo albums that are e-mailed to you? They usually say something like "follow this link for 85 photos of Johnny's first birthday." Those images, unless they carry a copyright (which is usually the case with photos taken by a professional photographer), can also be downloaded from the Internet for your own personal collection.

YOUR DIGITAL PHOTOS' HOME BASE

The best place to collect your digital photos is within a PC-based photo organizer. Most digital cameras come with one these days, and a number of good ones are available online as free downloads. (I give details on my favorite photo organizers in the next chapter and describe the basic process of getting your photos organized in them.)

These photo storage programs are just that: a place for you to collect the digital images of your life. But they also have some highly useful features built in. You can name your photos; organize them by name, date, keyword. You can rate your photos and perform basic editing steps such as cropping and color adjustments. You can create folders and subfolders of folders and play slide shows on your computer screen. You can print your photos and copy them onto CD-ROMs to share with family and friends.

Think of this software as your digital photos' home base. I have more than 5,000 digital shots in mine, organized by event folders, so I can click on my "Christmas 2005" folder and see those images. And the shots in my organizer are not just from my own camera: They include images from my father-in-law's digital camera as well as my parents' camera. It also includes old family pictures I've scanned.

Although such a tool is no longer necessary to enjoy digital photography—you can bypass the computer entirely by taking your digital camera's memory card directly to your favorite photo store for printing—I highly recommend using one for our going digital purposes. Such a tool, loaded with your digital photos, is the door to all the fabulous things you can do with your photos.

WHAT YOU CAN DO WITH YOUR DIGITAL PHOTOS

The possibilities are endless, and they are what much of this book is about. Once the photos are in your photo organizer, you can

- Delete the ones you don't like
- Edit the ones you do like, to make them even better
- Print them at home, at a retail store, or online or have prints delivered to your home
- Share your digital photos online
- Watch your shots on television
- Make digital photo albums, which can be shared on CD-ROM
- Order fantastic-looking, bound, hardcover books full of your shots, with captions

That's a taste of what's to come. More on all of these and other possibilities later.

WHAT ABOUT DIGITAL HOME MOVIES?

On the home-movie front, film-based analog videos have a single destination—your VCR. You can watch exactly as you captured them: Every moment must be viewed. And for me, there's nothing worse than the terrible, endless drone of home video narration ("Look! There's Mickey!"). Editing is complicated and clunky—usually done between two VCRs—and for most people, it's not feasible.

If you digitize your home movies, you can edit them on your computer, cut out the boring parts, and add cool titles, transitions between scenes, and even mood music. You can add relevant voice narration as you edit (have your son or daughter recall the moment being displayed, perhaps). Then the whole thing can be

GOING DIGITAL WITH HOME MOVIES

(Or, guaranteed ways to make Mom and Dad cry tears of joy)

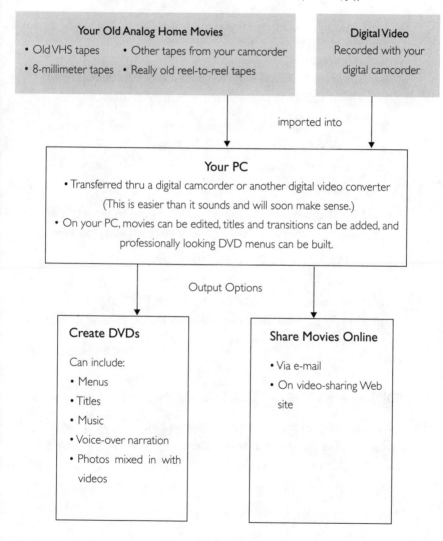

Your Old Analog Home Movies
- Old VHS tapes
- 8-millimeter tapes
- Other tapes from your camcorder
- Really old reel-to-reel tapes

Digital Video
Recorded with your digital camcorder

imported into

Your PC
- Transferred thru a digital camcorder or another digital video converter
 (This is easier than it sounds and will soon make sense.)
- On your PC, movies can be edited, titles and transitions can be added, and professionally looking DVD menus can be built.

Output Options

Create DVDs

Can include:
- Menus
- Titles
- Music
- Voice-over narration
- Photos mixed in with videos

Share Movies Online
- Via e-mail
- On video-sharing Web site

shared online, through various Web sites I'll introduce later, or burned to a DVD with professional-looking menu screens.

Doing this is easy, relatively affordable, and, best of all, fun!

WHERE DIGITAL VIDEO COMES FROM

As with photographs, the *Going Digital* process for your home movies begins with the video, not the digital camcorder. As with photos, digital video can come from a variety of sources:

- *Right from your digital camcorder:* Nearly every consumer camcorder sold today is of the digital variety. This means the camcorder can connect to your PC, and you can import the video to your computer.

- *Old VHS or 8-millimeter tapes:* Just about any video on these kinds of tape can be transferred to your computer and made digital.

- *Really old reel-to-reel tapes:* This gets trickier. For these kinds of tapes, most which were made prior to 1975, you'll need a third-party professional to transfer to VHS (so you can import it to your PC), or, if you like, directly to DVD.

YOUR COMPUTER IS YOUR DIGITAL MOVIES' HOME

Just as with digital photos, you can edit and play with your home movies on your computer. I'll cover the best movie editing tools in chapter 2. With these tools, you can

- Add titles
- Add transitions between scenes
- Add background music
- Add voice-over narration

- Mix in photographs with your movies, creating a true multimedia memory
- Share your movies via the Internet
- Create DVDs with professional-looking menus

CONGRATULATIONS!

By reading this far, you know more than the vast majority of people about the wide range of rewarding activities you can take advantage of with your digital photos and home movies. Now that you know what's possible, it's time to dig a little deeper. I'll cover each area in detail, and, before you know it, you'll be going digital with the best of them.

THE BIG PICTURE:
THE WONDERFUL WORLD OF DIGITAL

To sum up:

- Take it one step at a time with this book. Start with the techniques that interest you most, get comfortable with them, and move on. Feel free to jump around if you don't want to read this book from start to finish.

- Digital photos and movies can be put onto your computer for editing and manipulation.

- Film-based photos and movies are static; they simply exist. Film photos are developed. Film-based video is simply viewed. But digital photos and movies are dynamic. With digital, you can create a vast array of end results using the same starting raw ingredients: photos and movies.

- The going digital process begins not with the camera and camcorder but rather with the photos and videos.

· And these can come from a variety of sources, including really old ones: film, slides, old tapes; most, if not all of the photos and movies in your home are fair game and can be digitized to create wonderful, modern, long-lasting memories.

Now that you have a sense of the great things you can do with your photos and home movies, let's dive into the tools that can make it happen for you.

CHAPTER 2
YOUR DIGITAL TOOLBOX
Everything You Need to Capture, Organize, Edit, Store, Share, and Enjoy Your Digital Photos and Home Movies

Fact: You probably already have a good portion of the technology you need to take advantage of the techniques described in this book.

Fact: Most of the great things you can do with your digital photos and home movies that I present in this book are quite affordable—and many of them are free.

Both points usually surprise audiences at my speeches. You see, most people own technology with far more life-improving applications than they realize. On the basis of current national averages, I can confidently say that you probably have a computer with an Internet connection—or you at least have access to a PC with an Internet connection at work, at school, at your local library, or at your community center. I can also reasonably predict that you have some kind of photo camera in your home. Like I said before, a digital camera is not necessary to take advantage of digital photography. And with those three tech tools alone—a computer, an Internet connection, and a camera—you can execute many of the techniques in this book.

YOU DON'T NEED ALL OF THE TOOLS— JUST THE ONES THAT ARE RIGHT FOR YOU

This chapter describes in detail the technology items that make up a complete digital toolbox. They will help you take advantage of the fabulous possibilities of digital photography and video. But *you don't need all of the tools discussed in this chapter*. This is an all-inclusive list. You only need the ones that makes sense for the ideas and techniques that interest you.

Also, where applicable, I'll cover the most important variables to consider when you do go shopping for these technologies. You may be surprised at what's actually important when it comes to picking a tech tool. It's certainly not what the technology industry teaches us!

DIGITAL TOOLBOX LAYOUT

Your digital toolbox has three sections: a core set of tools, a recommended set, and some optional tools. If you were to have only three items for going digital, I think a digital camera, digital camcorder, and a PC with Internet access and a DVD recorder would get you the most mileage. In fact, you could accomplish many of the techniques in this book with just those three items.

To round your toolbox out, I suggest a printer designed especially for photographs; a photo scanner to digitize your old snapshots, film, and slides; and software—some of which is free—to organize your photos, edit your home movies, and create DVDs.

Finally, there are some optional tools. Ironically, you probably have at least one of these tools already—but you may not have thought about using it for your digital photos and movies. These tools include a cell phone with a built-in camera, photo-editing software, a film camera, your television, and a digital photo frame.

YOUR DIGITAL TOOLBOX

Core Tools

- Digital camera
- Digital camcorder
- A computer with Internet access and a DVD recorder drive

Recommended Tools

- Photo printer
- Photo scanner
- Software: photo organizer, video editor, and DVD creator
- External hard drive

Optional Tools

- Camera phone
- Software: photo editor
- Your film camera
- Your TV
- A digital photo frame

ALL THE QUESTIONS I'M ASKED SO OFTEN

Long ago, I said that one day I would write a book about all the questions people ask me about going digital. You see, people often ask similar questions; they're concerned about the same things. My friends who are doctors have experienced this. So have lawyers, accountants, reporters, and probably anyone who works in a specialized field. People are generally interested in, or concerned about similar things when it comes to going digital.

In this chapter, it's my goal to answer the questions that people ask me most often about each of the tools we discuss. So, get your questions ready, because in the pages below, I hope, I've put together the answers.

CORE TOOLS

Digital Camera

My father-in-law, Ron, is a fascinating case study in going digital. Until recently, he photographed exclusively with a large 35-millimeter film camera. It had a big lens and a big flash, and it went everywhere with him. I kept talking to him about all the great developments in digital cameras. Prices were plummeting. Quality was skyrocketing. And the photographs looked fabulous. Finally he took the dive. And as with most things Ron does, he took the dive in a very big way. He jumped in with both feet (and arms), and today, he's often teaching others—and, I must admit, sometimes even me—about the neat things he does with his digital pictures. Luckily, he has given me permission to tell his story, and so throughout this book, you'll be reading a lot about Ron. His is the story of an ordinary guy who went digital very happily and successfully.

Ron is a top-notch photographer. For a couple of years now, he has been using a big, heavy, top-of-the-line digital camera. It's the digital version of his old

film camera, the kind of camera on which you can swap lenses and flashes. He paid more than $1,000 when he bought this digital camera. He lugs it everywhere (in a video camera bag—the only kind it fits into). He takes excellent pictures with the camera, uses it all the time, and often preaches what a fine instrument it is. Since he has owned this camera, he has snapped over 20,000 pictures with it! (He knows this because he has kept every one of them. They're all on his hard drive. Ron rarely takes advantage of the great digital camera feature that lets you delete the photos you don't like. He likes them all.)

But one day, without warning, he bought a tiny digital camera, about the size of a deck of cards. He pulled it out of his front shirt pocket and proclaimed proudly, "Look. It's for when we travel and go out."

The point: there are hundreds of digital cameras on the market today, and almost all of them do a fine job of taking good pictures. In fact, most of today's digital cameras have progressed optically beyond comparable film cameras. Which means, in general, that most digital cameras take better pictures than most film cameras. And in the end, it's hard to go wrong with a digital camera. If you stick to cameras from mainstream manufacturers—Kodak, Canon, Nikon, and so on—available at mainstream electronics or specialty camera stores, online or offline, chances are that you'll be buying a fine camera.

Already Have a Digital Camera?

If you already own a digital camera that you purchased less than three years ago, it will probably suit our purposes and you need not buy another one. Unless, of course, you have the urge to go shopping for a new camera. If that's the case, by all means, scratch the itch! Otherwise, your camera will do the job just fine. Sure, there are smaller, prettier, and newer cameras on the market today, but they take photographs that are not significantly better than the camera you have.

If you have an older model, you don't necessarily have to run to your electronics store with credit card in hand, but know this: Your camera's lens, and the technology inside of it, is markedly behind what's on the market today. Of course, you can still take digital pictures with your camera and take advantage of many—but not all—of the techniques described here. But the quality of your shots will not be on par with those taken with cameras that are available today.

What to Look for If You're Shopping for a Digital Camera

If you're on the market for a digital camera, here's what to look for, in order of importance:

How Does the Camera Look and Feel in Your Hands?

Of all the variables involved in selecting the right digital camera for you, comfort and convenience are the most important. Are you surprised by this? Most people are. Because of how we've been trained by camera manufacturers, most people immediately believe that technical specifications are most important. They're not, because most digital cameras available today are a safe bet. Many times, they're more affordable than their film-based cousins. And because so much research and development goes into making digital cameras, you can be confident that most digital cameras take better pictures than comparably priced photo cameras.

And remember: This is the camera you'll be using to capture the moments of your life. Which is why the camera's "comfort" in your hands is most critical. Is it too heavy? Too light? Too big? Too small? Are the buttons easy to get to? I have big hands, so tiny cameras are hard to use. If you have small hands, you might not want a big, heavy camera.

Of course, to find out if a camera feels right in your hands, you have to get to an electronics store to touch and feel—and to ask questions. (I'll tell you later which ones to ask.) You can buy your

camera online, but just as you wouldn't buy a mattress without lying on it first, I wouldn't recommend buying a camera online until you get to personally experience it at a store.

Decide What's Most Important to You: Point-and-Shoot Convenience and Portability or More Technical Photographic Features and Functionality

Rule of thumb: the bigger the digital camera, the more functions it has. And the bigger a camera's lens, the more light it processes and the better the photographs. With this in mind, the technology and photography industries have categorized digital cameras into three major categories (the same categories are used to organize film-based cameras).

· **Point-and-shoot:** These are the smallest, simplest cameras, and prices range from about $100 to $400 on the high end. There are few manual functions on these types of cameras. (You cannot, for example, control f-stop speed or exposure or manually focus the camera.) Everything happens automatically. You simply point the camera and shoot the picture. The point-and-shoot cameras that cost the most are the smallest ones—they can fit into your front shirt pocket.

But these being the smallest and simplest cameras does not mean that they take bad pictures. On the contrary, most take excellent shots with a minimal amount of work.

· **Prosumer:** Combining the words *professional* and *consumer*, *prosumer* is the middle category of digital cameras designed for hobbyist photographers. I own one of these—they're larger than point-and-shoot models and they have bigger lenses. There are more manual functions. You can manually control things such as exposure levels, aperture, and focus. But there's also a point-and-shoot option. That's how I usually use my prosumer camera: in the point-and-shoot mode. Are the shots

better than on smaller, less expensive point-and-shoot models? I think so. Because the lens is bigger, prosumer cameras process more light than most point-and-shoots—thus better, crisper, brighter, more detailed photos. Prices for prosumer cameras range from about $400 to $800.

· **SLR:** This term represents the highest-end of digital cameras, the kind my father-in-law, Ron, had been using over the last several years. The acronym stands for *single-lens reflex*, a fancy term that for our purposes boils down to this: SLR cameras have large, interchangeable lenses that connect to large camera bodies. You can attach big flashes to these as well. Everything has manual controls, but here too, you can use these cameras in point-and-shoot mode. In fact, there has been a "consumerization" of SLR digital cameras in recent years, and entry-level units starting at around $900 are being marketed right at you and me.

These are the most photographically technical digital cameras. To get the most out of an SLR camera, you'll need to know a lot about photography. They're the least portable of the bunch, as your bag will contain not only the camera itself but also various lenses and flashes. The point: if you want straightforward and portable, this is not for you. If you want total photographic control and portability doesn't matter to you, think about an SLR. These are for serious photographers, and they cost serious money: $900 and up into thousands of dollars.

So which one should you get? For most people a point-and-shoot digital camera is plenty. If you're a photography enthusiast and like to tinker with settings, however, you should consider a prosumer camera. It will cost you 50 to 100 percent more than a point-and-shoot, but if you plan to use the manual functions, it will be worth your money. Finally, an SLR camera is for profes-

sional photographers and those who really have the time, budget, and understanding required to use it.

Now, and Only Now, Look at Technical Specifications

Most people think megapixels determine picture *quality*. They do not. Rather, megapixels determine the *size* of a photograph. The bigger the megapixel rating on a digital camera, the bigger the print that you can make from that photograph.

Here's the bottom line when it comes to megapixels: What's on the market today is more than good enough for most consumers. There's nothing being sold that's less than 3 megapixels today, and you'd be hard pressed to find cameras with less than 4 megapixels of resolution. The cost for a basic point-and-shoot 4-megapixel camera is about $200.

At 4 megapixels, the largest print that you can make at full picture quality is 11 × 17 inches, and how many of those do you think you'll ever make? At 3 megapixels, you can make full-quality 8 × 10–inch prints. Most people simply won't need anything more than 4 megapixels.

Do you really need an 8-megapixel camera? (There are a number of these being sold today.) Not unless you are photographing professionally for an advertising or graphic design firm. Just as the processing power of a top-of-the-line computer will be underused by nearly everyone who buys one, an 8-megapixel camera is overkill for most people.

What About Cropping?

When you crop photographs, you cut away a portion of the picture, and what's left is automatically enlarged to fill up the picture. It's probably the most-executed edit of digital photographs by consumers like you and me.

Here's an example of cropping: You have a photograph of your children, and there's a stranger appearing in the background edge

of the photo. You would crop that uninvited stranger out of the photograph, and, now, your kids would be enlarged to take up the entire photograph.

If you think you're going to crop a lot, consider a 5-megapixel camera. But let's come back to our example. If you have a 4-megapixel camera, you can crop that stranger out of the photograph and still make a beautiful 8 × 10–inch print (and any size smaller than that). This 8 × 10 is quite big compared with the 4 × 6 we usually have developed at a store. You will not, however, be able to make a full-quality 11 × 17–inch print, because you've cropped the photograph, and it is no longer its original 4-megapixel size.

This is a confusing and somewhat technical process that works something like this: 1 megapixel is 1 million pixels. Pixels are the tiny dots that make up your photographs—on the computer screen and on paper. When you cut away the stranger in the background, you've cut away a half-million—perhaps a million—pixels, and your photo, which originally had 4 megapixels, now has less.

Back to what all this means to you: The larger the megapixel rating on your camera, the bigger the print that you can make. And for nearly all of us, the cameras at the local electronics stores are good enough.

Zoom Right by the Digital Zoom

Digital cameras come with two kinds of zoom: a digital zoom and optical zoom. Digital zoom doesn't matter at all, and it's used, basically, to artificially inflate the technical specifications of a digital camera so it can rate better than the camera next to it. Optical zoom is the *lens's* ability to get you closer to the subject you're photographing. Most digital cameras today have at least 3× optical zoom, meaning you can get three times closer (than the actual, real-world distance between you) to the subject.

Digital zoom is accomplished by a microchip inside the camera

and thus decreases the quality of the photography. I tell people to simply turn off their camera's digital zoom—in the camera's setup menu, which is navigated to on the back of the camera, on the LCD screen. Digital zoom hurts the quality of your photos, so there's no reason to use it.

The LCD Screen

On the back of the digital camera is an LCD screen. That's where you frame your photo and review pictures you've already taken. You can also navigate your camera's menus here and delete photos you don't like from your memory card. Today, most cameras have an LCD screen of between 1.5 and 3 inches diagonally. It's simple: The bigger the screen, the more detail you can see in the photos you're taking. But also, the bigger the screen, the higher the price of the camera.

This should be a secondary concern when it comes to picking out your camera, but do be aware of the screen when you check out the various cameras before making a purchase.

Memory Cards and Other Accessories

Digital cameras capture photographs to memory cards instead of film. And just as film doesn't come with analog photo cameras, memory cards don't come with digital cameras. So plan on spending another $25 to $75 or so for a memory card. Don't buy a card smaller than 512 megabytes; a 1-gigabyte (1,000 megabytes) is preferable. The bigger the memory card, the more photos it can store.

Also, as is typical with today's technology, there are many different *kinds* of memory cards. There is the MemoryStick PRO, MemoryStick PRO Duo, SD (secure digital) card, miniSD, (extreme digital) xD card, and the MMC (multimedia memory card). But here's the saving grace: Each digital camera can typically only accept one kind of memory card. Some Sony cameras are the ex-

ceptions to this rule, as they sometimes accept two different types of memory cards.

Since you're probably going to be buying a memory card at the same time you're purchasing your digital camera, *make sure you know what kind of memory card your camera accepts*. It should be clearly marked on the box, and if you have any doubts, ask a salesperson. If you do buy the wrong card, most bricks-and-mortar retailers will allow an exchange.

Look for How the Camera Connects to Your Computer

An increasing number of digital cameras come with docks. These are small stands that are always connected to your computer. When you want to transfer photos from the camera to your computer, you simply place the camera into the dock and press a button on the dock, and your photos are moved to your computer's hard drive and, if you choose, automatically deleted from your camera's memory card. When the camera is in the dock, its battery is usually charging too.

Most digital cameras, however, simply connect to your computer with a cable—called a USB (Universal Serial Bus) cable—that plugs directly into your camera. For most people, this is fine, but some prefer the convenience and tidiness (no wire laying across your desk) of a dock.

Those are the keys to determining what camera to purchase. Most importantly: pick the camera that feels the best to you, and the one that has the ease and portability—or options and manual controls—that you want.

Which Manufacturer Is Best?

When you're deciding on brands, look for the mainstream *camera* manufacturers. Which means if you buy a camera from a company known for making cameras, you can be comfortable that you're buying a solid digital camera. These companies include Ko-

dak, Canon, Nikon, Fuji, and Konica Minolta. I suggest buying from camera companies—instead of companies that sell computers or televisions—because these companies have been making photographic equipment for decades. (Some of them have been making cameras for over a century.) They are specialists in *optics*, or the lens and light processing within the camera. Remember, it is the optics that determine the quality of the pictures your camera will take.

This is not to say that companies that deal more generally in consumer electronics—companies that are not solely camera specialists—don't make good cameras. My prosumer digital camera is made by Sony, for example. Sony has been making video camcorders for years and makes excellent digital cameras.

These days, even computer companies like Hewlett-Packard manufacture digital cameras. But they are computer and printer specialists, and while HP's cameras are solid, I would no sooner recommend that you buy a flat-panel television from a computer company than I would suggest that the best digital cameras come from computer manufacturers. It so happens that HP's digital cameras are well made, and priced reasonably, but from a purely optical standpoint, you're better off with a unit from a company that has more experience in making cameras.

Standard Warranties and Extended Protection Plans

Also, and this goes for every bit of technology we'll discuss, make sure the camera you're considering has at least the industry-standard warranty: one year, parts and labor. If you buy from reputable companies, through reputable retailers, this should not be a problem.

Should you buy the retailer's extended warranty? I never have. I've always felt that a $100 extended warranty that buys me two additional years above and beyond the original manufacturer's year of coverage is money that could be used toward a brand-new camera

when something goes wrong with the one I'm buying. Plus, who's to say I'm going to want this camera two years from now?

Experts are fond of saying that extended-warranty revenue is "free profit" for retailers because it usually costs them nothing, and most people never make use of their policies because today's consumer electronics are built well and, with basic care, can last far more than three years. But for many people I've talked to, the extended coverage buys peace of mind, and if you're one of those people, that peace of mind may be worth it.

If You're Shopping for Your First Digital Camera, Start Inexpensive

If your next digital camera will be your first digital camera, go with a nice entry-level point-and-shoot model for no more than $300. It will take very good pictures, and you'll get to try out digital photography with a perfectly fine camera for a reasonable price. And you'll certainly be able to take advantage of the going digital techniques described in this book.

You may very well decide that a point-and-shoot is all you need and be happy with your camera for years. But if you think you want to step up to a prosumer or even a high-end SLR digital camera, you'll still be able to use your small, convenient, easy-to-throw-in-your-purse-or-beach-bag point-and-shoot camera. Get my drift? Start with a point-and-shoot, and even if you upgrade—soon—you'll still get plenty of use from it.

Your Film Camera

A film camera as part of your digital toolbox? You betcha. Your film photos, along with your 35-millimeter negatives, are perfect for scanning—thereby digitizing—into your computer. So keep that film camera handy.

Also, start thinking about where all those old family photos are. Later, I'll discuss some wonderful ways to improve them and

share them with friends and family. Imagine the pleasure and surprise you'll give your family when you show them pictures of events and occasions that they haven't thought about in years!

A Digital Camcorder

These days nearly every camcorder being sold at consumer electronics stores such as Best Buy and Circuit City is of the digital variety. That's the kind you want, because digital camcorders create movies that can be transferred to your computer, edited, and shared online or via DVD. A scan of the Sunday newspaper ads reveals that today's camcorders

- · Are digital
- · Range in price from about $250 to more than $1,000
- · Record on Digital8 (digital 8-millimeter) tapes, MiniDV (miniature digital video) tapes, DVD, and, increasingly, large-memory cards. These are the same memory cards that are used by digital photo cameras.

What's Important When Picking a Digital Camcorder?

Most consumer digital camcorders are similar and shoot very nice movies. So when you're shopping, I'd suggest taking a similar approach for digital camcorders as for digital cameras: Look and feel are most important. Put it on your hand, pop open the LCD screen, zoom in and out, and see which one feels best to you.

Same zooming principles apply: Only optical zoom is of importance when comparing digital camcorders, and you'll want to turn the digital zoom off once you purchase your camcorder. If you leave it on, you may use it, and that would harm the quality of your movie.

Also, note the size of the LCD screen; most are about 2 inches, but some are larger, and, to some people, this is worth the price increase.

Which Camcorder Should You Buy?

If you're shopping for a camcorder to shoot home movies, I'd suggest buying one that records to MiniDV tapes. These have been on the market for several years now, and they're the most affordable video cameras available, with excellent models available from top manufacturers such as JVC, Panasonic, Sony, and Canon for less than $400.

There are also high-definition (HD) camcorders available now, but these, like the highest-end digital cameras, are not for most people. You're interested in making home movies, not Hollywood productions. And unless you have a high-quality DVD player and (HD) television (which will cost you many times the price of the HD camcorder), you won't be able to see the HD quality your pricey HD camcorder is recording in. My technology rule of thumb applies: Most camcorders in the low-to-medium price range available at mainstream retailers will suit your moviemaking needs perfectly.

And there are also all-in-one camcorders, which combine photo and video functionality into a single device. Some all-in-ones can even take photographs of 5 megapixels and higher. Should you buy one of these integrated units? Probably not. It has always been my experience that stand-alone, dedicated technology performs better at the single function it has been designed for than combination devices do. For example, a 5-megapixel stand-alone digital camera will most likely perform better than one that's integrated into a video camera. And because of the higher price tag that's attached to all-in-one devices, you won't be saving money by purchasing one instead of two dedicated pieces—one for photography, one for video.

To sum up, buy a digital camcorder from one of the well-known manufacturers listed above. Buy a camcorder that records to MiniDV tapes. And for most people shooting home movies, there's little reason to spend more than $400.

A Computer with Internet Access and a DVD Recorder

A computer will help you take advantage of many of the fun techniques in this book. And while a PC is not necessary to enjoy digital photography or, for that matter, digital home video, you'll definitely get a lot more out of both if you combine them with your computer. This should not be a problem for most people, as a large majority of Americans currently have a computer at home. The good part: it need not be top of the line, or even close to it. In fact, if your PC is several years old, no problem! You can use it for organizing, editing, and sharing your photos and home movies.

Of course, your computer will need to be connected to the Internet, as many of the best sharing methods revolve around the Web. Although a fast connection is helpful, it isn't required. You can use a dial-up Internet connection (through an Internet service provider [ISP] such as America Online, or AOL) to upload photos, but it will simply take 5 to 10 times longer than a high-speed connection such as DSL or cable. Sharing videos online may not be attractive with a dial-up connection, however, because video files tend to be larger and it may take hours to upload a single movie. But you can certainly still edit your home movies and create DVDs, as these processes do not involve the Internet.

A DVD recorder is also of great value for creating DVDs of your photos and movies. If you don't have a DVD recorder (or burner) built in to your computer already, you can purchase an external DVD recorder for less than $100. Burners that are available at your local electronics retailers will suffice.

A Photo Printer

Like French fries and soft drinks, photo printers come in three sizes these days: small, large, and supersized. Today's photo printers make fantastic-looking glossy snapshots right in your own home. And you don't even have to connect them to your computer: Many accept memory cards right from your digital camera, and

you pick the photos you want to print on a screen that's built into the printer. Some printers also connect directly to digital cameras and print the pictures right from there.

Snapshot Printers

The smallest printers are called snapshot printers, and they usually make photos measuring 4 × 6 inches and smaller. They print borderless, which means the picture takes up the entire space on the paper, and they print very, very well. They make photos that look just like the ones you get at the store from film. If you don't need to make larger prints at home, this is a strong option. You can always go to your local photo retailer to make larger shots. Remember, however, that this kind of printer will only print photographs, while the larger printers can also print other kinds of documents, like word-processing files.

But a key advantage to their small size is portability: These are fantastic at a dinner party or family gatherings. (Some even have a handle and a rechargeable battery for added portability.) You can take pictures—actually, anyone in your group with a digital camera can take pictures—at a party, and then print them on-site. Remember Polaroid instant cameras? (They still make those by the way.) Snapshot printers offer us the digital version of those instant cameras. A photo or two to take home is a fantastic gift and keepsake for the friends and family in attendance at your event!

Many snapshot printers accept memory cards directly. You can take your memory card out of your digital camera and plug it into the printer, bypassing the need for a computer (more on this in chapter 4).

These printers typically cost between $100 and $200, but as with all home printers, remember to budget for ink cartridges and paper. For snapshot printers, ink and paper usually comes packaged together. (A box that costs $20, for example, might have ink and paper for about 50 photographs.)

Full-Size Photo Printers

Most full-size printers can make pictures of up to 8 × 10 inches. These are desktop printers, designed to be stationary. They also take photo paper, and some use eight or more different ink cartridges. These ink cartridges cover the color spectrum, and many printers even use a separate cartridge for a final glossy coating that protects your snapshots from spills and sunlight. You can configure these printers for any size paper, usually up to a maximum of 8 × 10 inches. Costs range from less than $100 to $500.

Supersize Photo Printers

If you're really into photographs, you may want to consider supersize photo printers. These babies can make borderless pages up to 12 × 12 inches and create poster-size prints of 13 × 19 inches. Wanting enlargements is understandable, but why would anyone want to print 12 × 12 pages at home? Easy—scrapbooking.

My wife is an avid scrapbooker. Even with all of our digital photos, she gets them printed at our local Walgreens, or Wolf camera, then cuts the photos down to the right size, glues them onto the page, and adds all kinds of decorative stickers, designs, and wording.

These supersize printers do that work for you. All you have to do is lay out the page on the screen using a scrapbooking program included with the printer, and the page is printed ready to be inserted into your book. Cost: $400 to $600.

Which Printers Are Best?

As usual with my technology recommendations here, it's hard to go wrong if you pick a photo printer from a mainstream manufacturer at your electronics store. Epson and HP are considered leaders in this category, and their products are top-notch. Kodak and Sony also make excellent snapshot printers.

Which One Should You Buy?

When you're deciding which printer to buy, your decision depends on what you think you'll be doing with it. A full-size printer provides the most flexibility at the best price—for around $100, you can print good-looking photos of all sizes.

But it could also be that you need none of these printers, and dropping your shots off at your local retailer will suffice. Try that first (details in chapter 4) if you don't already have a photo printer, and see if it works for you. If you think you'd rather print at home, then consider a printer. The two methods aren't mutually exclusive either. I have a full-size photo printer, and I use it for the larger, enlargement-type photos. My 4 × 6–inch shots go right to Costco, because the price is right (19 cents per picture) and so is the convenience.

A Scanner

A scanner is one of the most valuable tools in your digital toolbox, and although it falls outside the "core" classification, I highly recommend that your arsenal include a scanner. Why? Because a scanner is the conduit between your nondigital photographs, slides, and negatives—some from generations long gone—and today's world of digital possibilities. A good photo scanner can take any still image from any flat media and convert it into a digital picture that can be enhanced on your computer and shared instantly with friends and family via the Internet or used to create a sharp new print. (Yes, many times the purpose of scanning an old photo is to improve it and make a fresh, new, great-looking print—more on this in chapter 5.)

A good photo scanner should cost you no more than $200.

Scanners are also categorized by resolution, and you won't need anything greater than 3,200 DPI, or dots per inch. The higher the DPI, the better the scanner's quality. I own a 3,200 DPI Canon scanner that I purchased for about $150, and most

of the time, my scanner's resolution is set to between 300 and 600 DPI.

Most people discover after they buy a scanner that they'll rarely, if ever, use their scanner's highest resolution. The reason is that high resolution makes for very large file size. A 3,200 DPI photograph takes up hundreds of megabytes of hard disk space and, worse, can lead to computer freezes and restarts because it uses so much of your PC's processing power.

The leading scanner brands are Hewlett-Packard and Epson. Other companies, like Canon, make good machines too. Check the editorial and user reviews on CNET.com before you make a decision. You'll save a lot of money if you purchase your scanner online. More on this in the next chapter.

Photo Organizer

The photo organizer is where your digital pictures live. It's the digital version of your collection of well-organized photo albums. When the memory card in your digital camera is filled up, you transfer the photos to your computer's hard drive, where you can organize, manipulate, and share the pictures. Some people choose to organize their photos by using Microsoft Windows folders, but I recommend a third-party tool for a variety of reasons:

- You can organize your photos into albums (folders) and subalbums
- You can rate your photos (five stars, four stars, etc.) and then sort them to view your favorite shots together
- You can assign keywords to your pictures (*birthday*, *vacation*, *dinner*, etc.) and then search for them by keyword
- You can search photos by date ranges
- You can make many edits and adjustments to your pictures (such as cropping, removing red-eye, and making color or brightness adjustments) within this program

- Some of these tools let you make prints right from the program—either on your home printer or, better, you can upload your photos to a Web-based photo finisher and receive professionally printed snapshots in your mailbox within days (more on this option in chapter 5).
- Some photo organizers let you select your photos, lay out a photo album, order it, and have a hardcover custom album delivered to your door, usually for less than $20. I cover this option in detail in chapter 6.
- Remarkably, many excellent photo organization programs are free!

My wife and I frequently spend time with our photo organizer, iPhoto, on our Macintosh computer. Here are my three favorites—one for Windows-based PCs, one for Apple computers, and another with versions for both operating systems—along with the Web addresses where you can download them:

Picasa www.Picasa.com

Picasa is the leading digital photo organization program from Google. It's free. It does all of the above. You can also write captions for each photo. These are stored with the photo, so when you reselect the picture, your text will display too. Picasa also has a collage feature with which you choose one background photo and arrange a number of smaller pictures on it. This makes for a unique, artistic presentation of your pictures. Because it's free, there's no reason not to download it and at least see what this photo organization thing is all about.

iPhoto www.apple.com/life/photo

iPhoto is for Macintosh computers, and it comes installed on all new Apple computers. It can be purchased with the affordable iLife package, which also includes Apple's popular iTunes music software, iMovie video editor, and iDVD, the DVD creator.

iPhoto can also perform all of the functions listed at the beginning of this section.

Kodak EasyShare www.kodak.com
Available for both Windows and Mac computers, EasyShare is a free download from Kodak. It's a nice organizational package that can be used with digital cameras from any manufacturer.

Photo Editing Software

There are many books available on high-end photo editing programs such as Adobe Photoshop. But these tools are expensive (Photoshop, the standard by which all photo editors are measured against, costs about $600) and they are best suited for professionals. The learning curve is too high, and the functionality far exceeds anything you and I need to do with our family photos.

Plus, remember, the photo organizers recommended above have most of the editing features most people will ever need. Also, I'm a technology minimalist. The fewer tools, the better. The more things you can do within a single, integrated program, the better. That's why I suggest you do your basic editing within your photo organizer.

However, some people may need a more robust, dedicated editor to do things such as fixing skin tone of photo subjects and changing backgrounds. For this, Adobe makes a consumer version of its flagship program that's watered down and a bit easier to use, focusing on the editing needs of most family photographers.

Adobe Photoshop Elements www.adobe.com
Adobe Photoshop Elements is the consumer version of Photoshop, and it costs about $100. With this tool, you can do higher-end, more technical editing such as airbrushing facial features and removing unwanted blemishes in your photos. It's still more than most of you will need, but if you're interested in deeper image manipulation, Elements opens that door. Elements

also includes a useful photo organizer, with many of the functionality of the organizers listed in the previous section.

Corel Paint Shop Pro www.corel.com

Corel Paint Shop Pro is another good option if you want to take your photo editing beyond the basics. It's available as a free, limited-time trial download, so you can take a test-drive. If you decide to buy it, Paint Shop Pro will cost you about $60.

Tools for Your Home Movies

Stephan's Story

Stephan recently completed a terrifically rewarding project. For his mother-in-law's sixtieth birthday party, he and his wife, Julie, decided to give her a gift she would not soon forget. They set about collecting video from Julie's mom's life. They found old movies at her house, at their house, and in the possession of friends and family around the country.

"We had a Christmas video of Julie's mom from the time she was 1 year old," Stephan says. "And it was that old reel-to-reel, frame-by-frame film." So Stephan had that old film converted to VHS. Then he took all the VHS tapes and imported them into his computer, where he was able to work with the footage. He cut the scenes down, added transitions, titles, and a music soundtrack and even incorporated still photographs. "We also videotaped still images and brought those into the video," says Stephan.

Then, once his final movie was ready, he created a DVD menu system for it. There were menu selections such as "The Christmases" and "Mom and Dad." All of the footage couldn't even fit onto one DVD, so Stephan made two.

Stephan and Julie gave the discs to Julie's mom, and the family watched the movies of her life together to laughter and tears.

Do You Have Home Movies Gathering Dust on a Shelf or in a Closet?

When is the last time you've seen your wedding video or that old vacation video? And I don't mean the footage—I mean when is the last time you saw the actual cassette? I grew up with a video camera pointed at me. Whether it was breakfast or my birthday or our family vacations to Disney World, my dad's video camera came along. And back then, it was a shoulder-mounted monstrosity that connected to a VCR that hung on my dad's other shoulder. There are at least 20 of those VHS tapes from my childhood. Then came 8-millimeter video cameras; my folks have another 20 or so of those tapes. If your family is anything like mine, you have tapes around your home that are filled with the great moments of your life. But you probably haven't seen what's on those tapes in some time—maybe years.

There's good news: Today's technology makes it easy to digitize those movies, edit them on your PC, and make fabulous DVDs that can be shared with your family and friends on your big-screen TV.

The process of going digital with movies differs a bit from that with digital photos because you'll probably spend a lot more time editing and manipulating the movies than you will the photos. Many photographs are ready for printing and sharing right from the camera, without any editing. Most of the ones that do need some editing require only fast, minor modifications such as cropping. With video, you'll probably find that you want to trim away a lot of unspectacular footage, and you may want to add titles, transitions between scenes, some background music, and perhaps even some narration.

There are three basic steps to going digital with your home movies:

1. **Digitizing** the video, or importing it into your PC
2. **Editing** and enhancing the footage on your computer
3. **Outputting** the new movie, usually to a DVD

Here are the details on each of these steps, and the tech tools that can be used:

Digitizing Your Movies
From a Digital Camcorder

If your home movies are shot with a digital camcorder, your process is simple. This is because the footage is already digital, and you can just connect the camcorder to your PC using a FireWire cable and import the video. (FireWire is a cable that transmits data many times faster than the more common USB cable. Both connect your computer to external accessories, and more and more new tech products offer FireWire connections. Most digital video cameras feature FireWire connections.)

From VCRs, 8-Millimeter Video Cameras, and Other Nondigital Sources

If the video you want to work with was not captured with a digital camcorder, you'll need a tool in between your nondigital (or analog) source—these include your VCR and 8-millimeter camcorder—and your computer. You can't connect your VCR or any nondigital source directly to your PC. Because the footage on VHS and 8-millemeter tapes is not digital, your computer simply wouldn't know what to do with them. Thus, we need to use a digital video converter as a go-between.

A digital camcorder is the simplest, most straightforward go-between available. It can convert your analog video into digital video so that your computer can capture it to the hard drive. You can plug your digital camcorder into your PC with the FireWire cable and plug your VCR or 8-millimeter video camera into the digital camcorder (using the yellow, white, and red audio/video cables called RCA cables). With the right software running—more on this in the next section—just hit play on your analog source, and your computer will be able to capture the footage.

There are a number of stand-alone digital video converters, usually retailing for less than $50, but I don't recommend them because they're not dependable. Instead, I recommend movie-editing packages such as Belkin's Hi-Speed USB 2.0 DVD Creator that include not only the video editing software but also the connection wires that plug into your PC's USB or FireWire port on one end and into your video source (again using RCA cables) on the other end. With the kinds of all-inclusive packages described below, you can accomplish all three of the digital home movie steps with a single tool.

Editing Movies and Creating DVDs

The step-by-step process for editing movies on your computer is better saved for other, more technical books—or your software's manual—but, basically, it revolves around a timeline. You drag scenes into the order that you want them to play, and you can drag sound files, titles, and transitions onto the timeline as well. Here are the top home movie-editing packages:

Belkin Hi-Speed USB 2.0 DVD Creator $89.99 ·
www.belkin.com

Belkin Hi-Speed USB 2.0 DVD Creator is an all-in-one package the combines hardware and software designed for Windows-based PCs. It includes the cables that let you connect your VCR or nondigital video camera to your computer, the software that captures the video and lets you edit it, and the DVD design tools that let you make menus and create DVDs. As with most video-editing tools, you can incorporate a soundtrack, titles, and various effects with a click of your mouse.

Pinnacle Studio Plus $99.99 · www.pinnaclesys.com

Pinnacle's Studio Plus is for Windows PCs and is more complex than most. It includes a video capture card that must be installed inside your PC before you can start importing video.

This requires opening up your computer and installing hardware, a process that you may not be comfortable with. But if you know how to install a third-party card into your PC—or know somebody who does—this is a nice product. It also includes an external audio–video connector that plugs into the card you install. (Seems like an awful lot of work to capture video on PC without a digital camcorder, doesn't it?) The included movie-editing software is very good, and the DVDs it creates are terrific.

Adobe Premiere Elements $99.99 · www.adobe.com

If you have a Windows PCs, Adobe's Premiere Elements is probably the most inclusive, most feature-rich software available. But here's the catch: There's no digital video converter included, so if you want to use this program, I would highly recommend having a digital camcorder that you can use to import your older analog movies. You can purchase a third-party converter, but these often have issues with compatibility. The editing software is user friendly. Premiere Elements also makes excellent DVDs with great-looking menus.

iMovie and iDVD $79 · www.apple.com/ilife

For Mac users, these iMovie and iDVD programs are the holy grail of home movie editing. Both of these programs set the bar for ease of use and excellence in functionality for the entire industry—Mac or PC. Unfortunately, they're available only for Apple users. They're part of the larger iLife series, which also includes iPhoto (discussed earlier in this chapter) and iMusic. Movies are imported into iMovie and edited there, and DVDs are created on iDVD.

It would not be too extreme to say that if you really want to spend a lot of time with movies and making DVDs, you should seriously consider a Mac. It's designed for personal multimedia

like this, and these tools come installed on all new Macs. Of course, you're unlikely to run out and buy a new computer just to edit movies, but if money were no object, that's what I'd suggest you do.

An External Hard Drive

Whether you plan on going digital with photos, home movies, or both, an external hard drive is a sound investment. These plug into your computer via a USB or FireWire cable and can be used to store your movie clips, photographs, and music. At a cost of less than $1 per gigabyte, massive amounts of storage space have never been cheaper. You can easily purchase a 120-gigabyte external hard drive for well under $100, depending on the sale of the week (and in the next chapter, I teach you how to find the very best deal available—and pay even less!).

Don't Forget to Back Up

This is as good a place as any to say that if you're going to enjoy digital photos and home movies, it is imperative that you make regular backups of your files. Computers are far from perfect: They crash, they lose data, they sometimes simply die, never to be turned on again. *So back up your important files—and none are more important than your family photos and movies.*

You can back them up onto an external hard drive or CD-ROMS and/or DVDs. Ideally, these files should be in two separate locations in addition to your computer's hard drive, so backing them up onto an external drive *and* CDs/DVDs is best. And since your pictures and movies are likely being updated regularly, so should your backups.

Backups can be automated within Microsoft Windows. Set Windows to back up your pictures and video folders weekly or monthly, and you won't have to think about it again.

Your Television (with a DVD Player)

Your TV can be used to share your photographs and movies in the living room with friends and family, accompanied by food, drinks, laughter, and fun. It's a central location where, using your TV's yellow video input jack, you can

- · Plug in your digital camera to look at the photos you just took
- · Play a slide show right from your photo organizer if your laptop is plugged into the TV
- · Play a movie or photo slide show DVD you made on your PC

There's great value in moving your photos and movies from the computer to the main living space of your home, where they can be enjoyed with the people closest to you.

A Camera Phone

If you've purchased a phone in the last year, chances are there's a camera built in. Chances are also good that this camera is not nearly as good as your stand-alone digital camera and should not be used as a replacement for a dedicated digital camera. But most of the time, your camera phone will be the only camera you have with you (since most of us don't usually carry our stand-alone camera to and from work). This makes it usable for a wide range of everyday purposes we normally wouldn't use our dedicated camera for. I cover the uses and possibilities of camera phones in detail in chapter 7.

THE BIG PICTURE: YOUR DIGITAL TOOLBOX

To sum up:

- · Remember, you don't need all of these tools, or even most of them. Pick one or two of items from the "core tools" list and if you don't already have them, consider making the dive. But

even if you own nothing but a film camera, I'll teach you how to take advantage of the Internet and share your photos with friends and families the world over!

· When you're choosing a digital camera, the technical specifications are *not* most important. That the camera feels right and matches your needs is most important.

· A photo organizer such as the free Picasa is highly recommended as your pictures' home base.

· The movie-editing and DVD-making process is more labor intensive than working with photographs. You can get started with one of the $100 packages discussed here. The value you'll get from the finished products—and the happiness you'll bring to your family—will far exceed the amount of money you spend.

CHAPTER 3
GOING SHOPPING
How to Buy the Best Digital Tools at the Best Possible Prices
(Or, how to save money on any technology you'll ever buy)

In this chapter, you'll learn how to save a lot of money. I'll teach you how to find the very best price on the product you're interested in and *pay significantly less than retail price.*

You might be thinking, *Yeah, but is it legal?*

Not only is it absolutely aboveboard but also the manufacturers and retailers *want* you to pay less than retail. They actually advertise these deals! They just haven't yet been successful in getting the word out to you. You can't find these prices in your local Sunday newspaper's ads. Read on, and when you're finished with this chapter, you'll be armed with the resources that will enable you to pay significantly less than the best advertised price on any technology product that interests you. Best of all, you can extend this process far beyond technology: From furniture to flowers to food, you'll never have to pay retail again.

Meet Mark and Sherri

After all the holiday gifts were open, the wrapping paper thrown away, and the family on their way back home, Mark and Sherri finally got a moment alone. They had given great gifts. They received some pretty nice ones too. And, now that the gift giving was over, they had about $150 in Circuit City gift cards.

But they didn't buy the gift cards, and they didn't receive them as a present either. Rather, they had earned them—while they shopped.

You see, the couple did their shopping online, using a Web site called My-

Points.com as a portal to Internet retailers. This means they went to My-Points.com, linked to an Internet store where they wanted to shop, and for every dollar spent, they collected points. Now, with the holidays over, they redeemed their points—much like frequent flier miles—for the Circuit City gift cards. And they put the $150 in "shopping reward money" toward a new DVD recorder that connects to their television.

Such rewards are just one way you can save money, or in this case, *make money*, while shopping for nearly anything. There are myriad ways to save money when shopping online: from coupon and rebate Web sites to sites that track sales and promotions being run by retailers to point-counting sites. And while you can apply the process below to anything from furniture to flowers to food, the largest money-saving opportunities are in technology. So when you're ready to go shopping for digital equipment (or, for that matter, any technology), follow these steps, and I promise you'll spend a lot less than you would by simply going to the store.

YOU'VE DECIDED WHAT YOU WANT—NOW WHAT?

You've decided it's time to buy a new piece of technology. Or perhaps you're considering an upcoming high-tech purchase. Here is the process I suggest following. It will help you determine

- Which digital camera (or printer, scanner, computer, etc.) is best for you
- The *best reasonable price* you should pay. I say *reasonable* because you want to make sure you're buying from a credible retailer—online or offline. There are some big savings to be had, but if it sounds too ridiculously good to be true, especially online, it is. I'll show you how to find a Web-based retailer you can trust.

· How to save, earn, and receive additional savings, gift cards, or rewards for making your purchase

FIRST, HIT THE PRODUCT REVIEW WEB SITES

We're lucky, you and I. We live in a time where there's absolutely no guesswork to our shopping. Think about it: Thanks to the Internet, we don't have to spend a single penny before we know everything we want about a product. Detailed specifications are available. So are in-depth product reviews written by knowledgeable experts. And, most helpfully, there are Web sites where consumers just like you post their experiences with the product you're considering buying. If most people are happy with their purchase, you'll know it. If they think they made a mistake, you won't have to repeat it. Best of all, these Web sites are free to use and available to you from any computer connected to the Internet. For digital cameras, this is especially true. Start with these top digital camera review sites to narrow your options:

DPReview.com

The *DP* in *DPReview.com* stands for *digital photography*. Its impressively deep, well-organized reviews cover the latest digital camera releases, from the cameras' physical design to the convenience of their buttons and menus systems to the quality of their photographs. One of the most useful features here are the sample photographs posted for *every camera that's reviewed*. What a great way to judge a digital camera! Check out the photos taken with the camera you're interested in, and you'll have a much better idea of the camera's performance. There are also insightful consumer reviews listed here. Click on *Forums* to access them.

For each digital camera you're interested in, be sure to

browse through the *Introduction, Conclusion,* and *Samples* sections on this site.

Steve'sDigiCams.com

Steve's DigiCams is similar in its approach to detailed digital camera analysis, also giving reviews for the latest cameras. It's a fine alternative and second opinion to DPReview.com and provides yet another set of digital photo samples taken by the cameras you're interested in. The site also reviews photo printers and accessories. You can click on *Discussion Forums* for opinions and reviews by fellow consumers. There's also a dictionary of technical digital photography terms.

CNET.com

CNET is probably the most popular consumer technology Web site on the Internet, and for good reason. It provides detailed reviews not only for digital cameras, camcorders, scanners, printers, and PCs, but also for TVs, DVD players, MP3 players, cell phones, and literally every category of consumer technology available today. Reviews by CNET editors are available for many products, and the *User Opinions* section offers consumer reviews. Many products also have small video demonstrations too. There are product photos, and even small videos where you can see an expert interacting with and testing a product.

CNET also offers good buying guides and articles on nearly all consumer technology product categories and should be one of your first stops when you begin your shopping process. It's one of the first resources I access when researching products.

There are other product review Web sites, of course, but these, in my opinion, are the best for our purposes. And they've been around for many years and will be available, updated, and ready

for your product-research pleasure when you point your Web browser to them. Later on in this chapter, I'll show you where to find additional reviews by your fellow consumers.

NOW, GO TO THE STORE

Once you've narrowed your options to a few products, write down your favorite models and go to your local electronics or camera store to check them out in person.

With digital cameras, you'll probably get more personal, and, probably, knowledgeable attention at a camera store such as Wolf Camera, Ritz Camera Centers, or your local one-hour shop. But wherever you go, the purpose of your visit is to view, handle, and interact with the digital cameras (or whatever technology you may be shopping for) on your list of finalists. Almost always, the unit you're interested in will look or feel surprisingly different than you expected on the basis of your Internet research. It may be smaller, bigger, lighter, or heavier. It may be metallic when you expected plastic, or thin when you expected wide. Hold the camera in your hands, make sure you turn it on, and aim it at a subject, zoom in and out. How does it feel? Are the buttons positioned comfortably? Is the LCD screen large enough for you to view the picture comfortably?

Go through the same steps if you're checking out a digital camcorder. If you're looking at a printer, see if you can make a sample print to personally test the quality of output. If you're examining scanners, check the size of the unit. Will it fit into the space you envision for it? In general, get a feeling for a product's dimensions, look, feel, and quality.

Once you've finished your examination, leave the store. *You're not here to make a purchase . . . yet. Rather, you're at the store to further narrow your product options.* There are still lots of savings to be had, and for this you have to return to your computer

and the Internet. I'm not suggesting that you shouldn't make your purchase at a bricks-and-mortar electronics retailer. You certainly can, but only after you've determined which one has the best price. This determination is most easily done on your computer. So even if your wallet is burning a hole in your purse or pocket, turn toward the door and walk to the relative safety of the parking lot. You still have some money-saving work to do.

DEAL TIME: WHERE THE SAVINGS ARE

Let's Go Comparison Shopping

When Mark knows what he wants to buy, he turns to one of a number of extremely helpful, free-to-use comparison-shopping Web sites that do the time-consuming work of tracking down the best reasonable price. At their core, these sites display product prices from multiple retailers. But if you dig a bit, there's a bevy of useful information. Here are my favorite comparison shopping sites:

Shopping.com

One of the first and broadest of comparison Web sites, Shopping.com lets you search for the exact model number you're interested in or track it down by category. Once you've selected your product, Shopping.com provides you with a matrix listing retailers as well as their price and shipping costs. After you enter your ZIP code, exact shipping fees are calculated into the total price. Helpfully, this site also provides store ratings, which are consumer experiences with particular retailers (similar to seller feedback on eBay).

Consumer reviews and ratings of products are also provided. Click on *Read Reviews* to see what your fellow shoppers think of the item you're interested in.

Froogle

Go to Froogle (http://froogle.google.com) and you'll see a search screen remarkably similar to the Google search engine. That's because Google created this comparison shopper. Type in the product you're looking for and Froogle will display a list of matches. You can choose to view the matching products in the form of a table by clicking on *Grid View*. Froogle offers a helpful collated list of store reviews gathered from various comparison shopping sites. You can see these reviews for a given retailer, from multiple comparison shopping sites, by clicking on the rating, out of a possible 5 points, under the product listing. (It looks like this: *4.2/5.*)

BizRate.com

On BizRate, you can search by model name or click through product categories until you arrive at a list of items that match your interests. You can, for example, click on the following links: *Digital Cameras → Canon Digital Cameras → Compact/ Small* and finally, the model number of your choice. This Web site offers a matrix similar to that at Shopping.com. It lists retailers and countless reviews by customers who have done business with each. At the time of this writing, for example, more than 675,000 people had written a review for CircuitCity.com on BizRate. A retailer called BuyDig.com had more than 100,000 reviews. BizRate also offers the number of packages its retailers have in stock. This is a helpful feature if you need your item quickly.

NexTag.com

NexTag.com also provides a matrix for retailers, their prices, shipping costs, and seller and product reviews by fellow buyers. You can search by category here as well. There are two features, however, that separate this site from the rest. It offers a price history graph that shows you the fluctuations in items' prices.

This is useful because if the price is rising, it may be time to pull the trigger on your purchase. If it's falling, you may want to wait because it'll likely fall further. Also, NexTag features a "price alert" feature that lets you specify a target price for your items of interest; when retailers' prices hit that point, you'll be notified by e-mail. Talk about automating the shopping process!

PriceGrabber.com

Like all the others except Froogle, PriceGrabber offers nice categories to click through in search of your product, as well as a fine matrix that includes retailers, prices, shipping costs, and seller ratings. But what separates PriceGrabber from the pack is a tab atop the matrix called *Expert Reviews*. Click here to see a list of online and offline publications that have reviewed the product you're shopping for. Click on the reviewer and you'll be taken right to the write-up.

As you can see, these comparison shopping sites really do take the time-consuming legwork out of finding out the best reasonable price for your item. As a rule, if the lowest price is from a retailer you don't recognize and there aren't many ratings from buyers, pass it up. On all of these sites, you can click on a Shop or Buy button and go right to the retailer's online store.

All of the comparison shopping services discussed so far are fabulous and free, but they're only usable for Web-based retailers. What if you want to compare the prices at your local bricks-and-mortar outlets? Here too you're in luck.

ShopLocal.com

ShopLocal.com is a little-known, supereffective site that lets you compare prices on products sold at stores in your area. At the home page, you enter your ZIP code, and you're taken to your local page. You can find information in three different ways: by clicking on the store you're interested in (think Best

Buy, Circuit City, and Target), by searching for the product you're interested in, or by clicking through product categories until you arrive at the items that you're looking for. Click on the store, and you'll see that company's latest weekly circular from your Sunday paper. It's scanned, and the whole thing is interactive: You can turn the pages and click on items of interest for added details. Of course, the store's address and phone number are displayed. You can make a shopping list that can be printed along with store information. ShopLocal.com is an imaginative, effective tool that lets you plan your offline shopping online.

You can use these comparison shopping sites to get a good sense of your desired product's price range and best reasonable price, but don't hit that Buy button yet. Why? Because you can take a product's best reasonable price . . . and make it even lower!

Who Doesn't Love Coupons and Discounts?

Did you find a good deal? Great. Print the screen with the good deal, bookmark the page in your Web browser, or make a note to yourself on a piece of paper so you don't forget to return there.

Now, let's go shopping for discounts and coupons. Most people don't know this, but most large manufacturers and retailers offer coupon and discount codes that can be used during the online checkout. The industry offers these promotions through what they call affiliate Web sites, which compile coupons and discounts and link directly to the sellers' sites. For sellers, affiliate sites are an added source of Web traffic, accounting for an increasing percentage of total customers. For you, affiliate (or discount) sites offer additional savings on products you're probably going to buy anyway. Why not find the best price available?

Here are the most popular online discounters:

CoolSavings.com

The Web's most popular coupon site at the time of this writing, CoolSavings.com lists everything from grocery coupons to pet coupons, baby coupons to diet offers, and travel coupons. You'll have to enroll, which involves providing your name, address and e-mail address. CoolSavings has a variety of features, including printable coupons with bar codes for the grocery store. In the *Computers and Electronics* section, for example, one site advertises 50 free MP3 music file downloads.

FatWallet.com

One of the Internet's most long-lived discount sites, FatWallet.com has been around for years, offering coupons, price breaks, and, most usefully, lively discussion boards where your fellow shoppers identify the latest deals they've come across. You can turn to these discussion boards for rumors of upcoming discounts, many of which turn out to be true. You can search for deals and discounts by the specific product name or click on links such as *Most Popular Offers*, *Latest Deals*, and *Expiring Soon*. I clicked on *Most Popular Offers* at the time of this writing and found links to Dell ("Up to 40% off select electronics and accessories"), Amazon.com ("75% off clearance sale plus free shipping"), and Toshiba ("$200 off Portégé notebooks"). Not bad for five seconds' work.

CouponMountain.com

The following discounts were listed on the home page of CouponMountain.com at the time of this writing:

· Save $60 on electronics and accessories at Dell
· Free shipping at Hewlett-Packard
· Save up to $250 instantly on Hewlett-Packard digital entertainment

I dug a bit deeper and discovered these savings:

· DSL Internet access through SBC Yahoo for about $15 per month
· Save $25 on all orders at Nextel

Some of the links lead to coupon codes to be entered during checkout at a retailer's Web site. Other discounts link directly to sellers' sites, where the deals' details are listed.

Earn Points for Purchasing Goodies

Mark and Sherri earned their Circuit City gift cards while doing their shopping through a Web site called MyPoints.com. But they also get quarterly rebate checks (many of which are for more than $100) by using a service called Ebates.com.

"I go to Ebates and MyPoints and check out what's in it for me," Mark said. "Ninety percent of the time, the site [with the product I'm interested in] is listed there," bringing added savings, rewards, and rebates for buying something on which Mark was going to spend money anyway. If you're going to shop, you might as well be rewarded for it!

Ebates.com

Credit cards like Discover have become famous by offering a small percentage of your total savings back to you in the form of an annual cash rebate. Ebates.com has gone one better: It sends you *quarterly rebate checks, ranging from 2 percent to as much as 25 percent of your total purchase*, depending on the retailer. If you were to have shopped Circuit City and Office Depot, for example, Ebates was prepared, at the time of this writing, to send you a check for 2 percent of your total purchase. Best Buy was giving 1 percent back (not small potatoes on larger purchases). Looking for refills on your inkjet ink refills? 123inkjets.com was offering a 10 percent rebate. But

123lasertoner.com was offering 12 percent. Even shopping at Target would have netted you a 3 percent discount (and Target has good prices on electronics to begin with). To take advantage of these cash rebates, all you have to do is start your shopping at Ebates.com.

RebateNation.com

Both RebateNation.com and CashBackBuddy.com offer programs similar to that of Ebates.com.

MyPoints.com

Instead of dollars, MyPoints.com offers points, which can be redeemed for a variety of goodies. You have to go through a rather lengthy profile form to start using this site so that offers can be tailored to your interests, but it may well be worth the effort. Here's how this system works: by clicking through to retailers via MyPoints.com, you get one point for every dollar you spend. It's like earning miles for credit card purchases. Once you've amassed various levels of points, you can redeem them for gift cards and other items from electronics stores such as Wal-Mart, Office Depot, Circuit City, and Sharper Image.

Memolink.com

Another rewards Web site that tallies points for purchases is Memolink.com. It bears repeating: If you're spending the money anyway, why not reward yourself? You work hard for your money, and it's not easy to part with. You might as well take what they're giving you!

Upromise.com

If you have a child or grandchild who will be going to college one day, you may be interested to know about a Web site called Upromise.com. It puts a portion of your total purchases toward a college savings plan. Even if you don't have children, you can save "for a friend's child, a relative—or even a child you hope to

have in the future," the company's site says. At the time of this writing, the site claimed more than 40,000 retailers, including such electronics retailers as Best Buy, Office Depot, and Sharper Image. More than 20,000 grocery stores and drugstores and more than 8,000 restaurants are involved in its program. You register a credit card or debit card with Upromise.com, and you'll get a cash rebate for a child's upcoming college tuition for all the money you spend at the participating sellers.

NOW YOU HAVE ALL THE INFORMATION TO SAVE MAXIMUM MONEY

Research over. It's time to put it all together. You've found the top tech products through reading expert and consumer reviews, you've found the best reasonable price, you've located the discounts and deals currently available, and you've registered to receive rebates and/or reward points for your upcoming purchase. Now, if you're ready to pull the trigger, I feel comfortable in giving you the go-ahead. You're now armed with what may be the most effective money-saving process available to consumers. And while it's great for technology purchases, it's fabulous for nearly all your shopping—especially around holiday time! With this process, you can purchase groceries, greeting cards, flowers, furniture, and clothing and be confident you've worked out the best deal available anywhere for what you're buying. There's simply no reason not to save as much money as possible, and with this system, it's easy to work out for yourself the best possible price anywhere—and get rebates and rewards to boot!

THE BIG PICTURE: GOING SHOPPING

To sum up:

- Start by visiting comparison shopping sites, including Shopping .com, NexTag.com, BizRate.com, PriceGrabber.com, and Google's Froogle.
- Next, hit the discounters and coupon sites to see what deals your selected retailer might be offering. Check out popular coupon sites such as CoolSavings.com, FatWallet.com, and Coupons.com.
- Use services such as Ebates.com and RebateNation.com that send a cash refund for a percentage of your total purchase.
- You can amass points for your purchases, which can later be exchanged for goodies such as gift cards. Sign up at MyPoints .com or Memolink.com.
- ShopLocal.com collates digital versions of Sunday circular advertisements that list what's on sale in bricks-and-mortar stores near you.
- Upromise.com puts a portion of your total purchases toward a college savings plan for your children.
- Put it all together and you have what may be the most effective money-saving process available to consumers.

CHAPTER 4
PRINTING PHOTOS
How to Get Fabulous Snapshots That Look and Feel Like Photos from Film

Joe does it at home. Ron likes to do it at home *and* at the store. And Mary Beth does it on the Internet and through the mail. Just like them, you can choose from four major ways to get crisp, bright, sharp-looking photographic prints from your digital images:

1. Dropping them off and picking them up at your local retail photo lab
2. Uploading them to an online photo maker and having them delivered to your mailbox
3. Uploading them to a local photo lab, and then picking up your pictures in person—sometimes within one hour
4. Printing them at home

Whichever option you choose, your pictures will look fantastic. Most likely, they will look *better* than the photos you used to take with your film camera. This is because photographic technology, such as optics (lenses) and color processing, has advanced significantly over the last several years. Further, the commercial photo printers that retailers use have progressed tremendously recently, because commercial printer manufacturers such as Kodak and Fuji have had to adopt them for making prints of digital pictures. So the digital revolution in photography has not only spawned better cameras but also significantly advanced the quality of commercial printers. Even if you have a run-of-the-mill $200 digital camera that you purchased in the last couple of years, the pictures you get

printed will probably be better than the snapshots you took with your film camera.

AN IMPORTANT STEP BEFORE
YOU GET YOUR IMAGES PRINTED

Don't be alarmed, but there's a somewhat technical step that many people miss before having their photos printed. It's a very easy step, though, especially once you get the hang of it. Whether you're printing your pictures at home, bringing them in to a retail photo shop, or uploading them for pickup or delivery, the photos must be *cropped to the size that you want to print them, or some portion of your image will cut off.* This can be done in most photo programs, and it's most conveniently done in your photo organization software. Most programs call this *constraining* a photo to a certain size. So if you want to make 4 × 6–inch prints, you'd have to crop each photo, selecting the size constraint of 4 × 6 inches before you crop. When you do this, the program keeps your photograph in correct proportions for a 4 × 6–inch print, and everything you see on your screen will be printed. You can also choose to constrain your cropping to 5 × 7 inches, 8 × 10 inches, or any size you wish to print.

If you don't do this, there's a good chance your picture will be incorrectly proportioned, and your photo lab's printer will automatically cut off parts of the picture. This can result in lopped-off heads (photographically speaking, of course) and, as happened to me, the top of the Eiffel Tower being unceremoniously done away with.

If you want to know where the constrain feature is in your photo program of choice, open the program's help menu (I always hesitate recommending this, as most help features are anything but helpful) and search for the word *constrain* or *crop.*

As I said, this is a rather technical-sounding step. But it's really only one quick step. Crop the photo to the size you desire and save the file. That's it.

If you're uncomfortable with this, take your originals to your photo retailer and ask them to make sure your images are sized correctly for the prints you're trying to make. Some kiosks can handle this step, and most retailers will hold your hand through this process.

Now, the details on printing options:

OPTION 1: DROPPING OFF AND PICKING UP AT YOUR LOCAL RETAIL PHOTO LAB

The drop-off-and-pick-up process is the same one that we grew up with using film cameras, just modernized: Take your pictures. Take your memory card (or CD-ROMs, onto which you've copied your photos) to your local drugstore or photo lab. In most cases, you'll pop the card into an interactive kiosk. (You've probably seen these kiosks if you've been by the photo department of your drugstore recently: They have touch-screen monitors and a number of slots for a variety of memory cards, as well as a slot for CDs.) Select the photos you want to print. Pick the size for each picture. Go run errands. Return in an hour or so, and your pictures should be ready. Open the envelope. Thank the nice man or woman who runs the photo lab. Pay. Enjoy.

How much will you pay? It's amazing, really. At many places, the cost is less than 20 cents per 4 × 6–inch print! Think about that. You can get 24 digital photo prints in about an hour for about $4.50, which is far less than one-hour service used to cost for developing 24-exposure rolls of film. I say an hour because digital photos are printed on-site and are usually ready the same day, many times the same hour. (At most stores, it depends on the number of prints you're making. Three hundred pictures will not be

ready in an hour, but they probably will be ready the same day.) Whereas with film prints, where there was always the "regular" option—if you dropped them off at a drugstore, your pictures were sent to some remote photo lab—digital snapshots go straight to the store's printer, which is usually mere steps from the kiosk.

And remember, with digital, you're printing only the very best 24 photographs from the set you took. The ones you didn't like have been long deleted. (Unless you're like Ron, and keep everything! But even if you do keep everything, you certainly don't print the bad photos.) Plus, some of the photos you're printing have probably been edited a bit: Maybe you've cropped the photo to better center the picture or to remove that stranger in the background. Which means you're paying to print only your favorite photos, which you've enhanced. Not a bad deal all around.

NO COMPUTER REQUIRED

You can get a digital camera and still take advantage of many of its powerful features without a computer. With a trusted retail photo lab as your partner, you can use your digital camera much the same way as you would use its film-based cousin: take pictures, get them printed at the store, and have your digital picture files transferred to a CD-ROM. This will clear off your memory card, and instead of film, you'll receive a CD with your developed pictures. Cost to have a CD made: usually less than $3.

You can put the CD in a safe place and, when you want additional prints, just bring it back to your photo lab's kiosk, pop it in, and print the photos you'd like. If you want, you can even edit your photos on the kiosks. Basic editing, such as cropping and red-eye reduction, is now available right at the kiosk. Using the touch-screen buttons, you can even convert a color photo to black and white for printing.

You can also take the disc to friends or family members and

they can make copies on their computer of any pictures that they want. You can also have the photos manipulated at this computer or at a PC at your local library, Internet café, or community center.

A GREAT OPTION IF YOU LIKE TO TRAVEL

When my wife and I were traveling in France and taking all those digital pictures, retailers' kiosks were not as advanced as they are today. (The major advances have come in the last two years or so.) So we had to take a laptop with us so that we could transfer the pictures from our memory card to free up the card for new photos. Because we didn't want to purchase four or five additional memory cards just for our trips abroad, and because we didn't want to be limited to the number of pictures we could snap (I like to take lots of photos—just ask my wife!), we unloaded the shots to the laptop's hard drive every night and had a clean memory card each morning. This accomplished our goal of no-limit picture taking, but having to worry about a laptop was an inconvenience. There are security issues at airports and hotels as well. But at the time, it was our best option.

Today, there's a better option: Just take your memory card to a photo store and have the pictures copied onto a CD-ROM. At some kiosks, you can do this yourself, and at others, the store attendant will need to help. But either way, the discs provide a safe place to keep your treasured travel pictures and allow for unlimited shooting. If you're worried about losing or damaging the disc, have two copies made and keep them in separate places. For example, when you fly, put one set of CDs into your checked luggage and the other identical set into your carry-on bag. (On the way home from France, we had one set of photos on the laptop's hard drive, which was in our carry-on bag. And the backup set was on CD-ROMs I had made the day we left.) If you still don't feel secure, make a third set of CDs to ship home ahead of you.

HOW TO FIND THE PHOTO RETAILERS NEAR YOU

The Photo Marketing Association, a nonprofit organization representing the retail photography industry, has put together an extremely useful utility at its Web site for consumers.

Go to TakeGreatPictures.com and click on the *Find a Photo Lab* link. You'll be able to enter your street address, city, state, and/or ZIP code and receive a list of all of the retail photo labs near you, organized by distance from you. This is convenient for learning not only the locations of photo retailers near your home but also to find the closest lab to your hotel when you travel. If you click on the link to a store, you'll see the establishment's address and phone number, as well as the types of memory cards that are accepted there. Also listed is the largest photo size that the store can print. There are more than 20,000 photo retailers in the United States, Canada, the United Kingdom, France, Australia, Ireland, and New Zealand, among others, listed on the site.

You'll find that most of the photo retailers that come up on the list are chains. This is because the industry has undergone a massive consolidation as independent small businesses struggled (and most eventually failed) to adjust to digital photography's lightning-fast arrival in the mainstream. So you'll see stores from large chains such as Walgreens, Wal-Mart, and Costco most often, followed by photo specialty franchises such as Wolf Camera and MotoPhoto. And every once in a while, you'll see an independent mom-and-pop shop.

At all of these photo labs, you'll find experts who will be able to guide you through the kiosk process; and you ought to have some help the first time you use one. Ask questions and expect answers. These are your precious photographs we're talking about.

THEY MAKE MORE THAN JUST PRINTS

At nearly all photo retailers, you can order far more than just prints. You can, for example, make calendars with your pictures. You can also order mugs, mouse pads, T-shirts, greeting cards, and even kitchen aprons emblazoned with your favorite photos. But more on all these options in chapter 6.

OPTION 2: UPLOADING IMAGES TO AN ONLINE PHOTO LAB AND HAVING PICTURES DELIVERED

Mary Beth gave birth to twins six weeks prematurely during a particularly harsh winter. So she was stuck at home with the twins, her third child, and her Canon digital camera. As would be expected, she took lots of pictures. She transferred them to her Apple laptop, using iPhoto as her photo organizer. Everything was going great until, as often happens with technology, her photo printer broke.

"I had about two hundred digital photos," Mary Beth says, "and I had no idea what to do with them. I was actually dragging my laptop out to dinners to show the pictures to my friends." Her pictures literally were digital—and only digital. She wanted prints. But her printer was broken, and she had no way to pick up prints because of the babies at home and the weather outside.

Then one day she got an e-mail from a photo-finishing retailer called 30 Minute Photos Etc. "Upload your digital images to us," read the marketing message, "and we'll send you real photographic prints." So Mary Beth, who lives in Philadelphia, decided to try it, and using the company's Web site (http://www.30minphotos.net), she uploaded her digital pictures to a single-store small business based in Irvine, California.

Three days later, the photos arrived in the mail, completing their round-trip cross-country journey (traveling via the information superhighway one way and via the U.S. Postal Service the other) in Mary Beth's mailbox.

How did the pictures look?

"The quality was terrific," she says, "and the convenience of receiving my prints three days later by mail was excellent."

This option is the digital version of those mail-order services that were popular in the 1980s and early 1990s; you sent your finished rolls of film to a mail-order developer and received your pictures back by mail in the same envelope you sent them in. Today, you can upload your digital pictures to thousands of photo finishers. The process works like this:

- Point your Web browser to the Web site you want to order prints from (see "The Online Retailers" below).
- Click on a link that reads *Upload Photos* or something similar.
- File by file, select your pictures and upload them. (As you might imagine, Mary Beth's 200 photos took quite some time—and quite a lot of mouse clicks—to transmit. Even uploading 50 pictures is a labor-intensive process.)
- Once you're done uploading, select the print size for each picture.
- Then you'll enter your name, address, and credit card number, and in a few days your prints will arrive in your mailbox.

As you will see, as is often the case with any fast-developing technology, prices are all over the place. For example, at the time of this writing, prices for one 4 × 6–inch print ranged from 12 cents to 29 cents, and the price of one 8 × 10–inch print ranged from just $1.50 to $4.

At which Web sites should you do this?

THE ONLINE RETAILERS

Though these Web-based printers don't have a bricks-and-mortar presence in the offline world, they have been around for years and can be trusted to provide top-notch prints of your digital pictures. All of the prices listed below are as advertised at the time of this writing:

KodakGallery.com

Formerly Ofoto, Kodak EasyShare Gallery sells 4 × 6–inch prints for 25 cents each if you're making less than 100, and for 19 cents each if you're making 100 or more. A 5 × 7–inch print costs about $1 and an 8 × 10 is about $4.

Shutterfly.com

Shutterfly charges 29 cents for 4 × 6 photos, about $1 for 5 × 7s, and about $4 for 8 × 10s. Volume discounts on prepaid plans are generous and can reduce costs to 19 cents per print.

Winkflash.com

This is a lesser-known site with a very affordable price structure and a fine finished product. Winkflash charges just 12 cents per 4 × 6 print, less than half of many of its larger competitors! For 5 × 7 inch shots, the cost is just 29 cents, and 8 × 10s will run you about $2. This site also offers remarkably large poster-size prints, all the way up to 44 × 66 inches. You can purchase a 2 × 3–foot photograph for just $20 here.

Snapfish.com

This site has been around for a long time and currently sells 4 × 6 prints for 12 cents. Their 5 × 7 shots cost 79 cents for fewer than 10, and significantly less if you're making more prints. Their 8 × 10s run about $3.

PePhoto.com

With one of the lowest costs-per-print on the Internet, PePhoto.com offers 4 × 6 snapshots for 9 cents each. Remarkably, this site prices its 5 × 7 prints at a mere 18 cents, less than what many sites charge for smaller sizes.

LARGE RETAILERS' WEB SITES

Large chains such as Wal-Mart, Walgreens, and Target offer home delivery as well, often for a lower cost per print than their online rivals. These companies' real strength, however, comes from the upload/in-store pickup option, which is discussed in detail in "Option 3: Uploading Images to a Local Photo Lab and Picking Up Photos." You can use the following Web sites to upload your photos and have them delivered:

WalMart.com

Charges 12 cents per 4 × 6–inch print for photos delivered to your door, 58 cents for a 5 × 7, and about $2 for an 8 × 10.

Costco.com

This large discounter's photo site is powered by the Snapfish service which is described above. Costco charges 17 cents for a 4 × 6, and just 39 cents for a 5 × 7, and about $1.50 for 8 × 10s.

Walgreens.com

Although home delivery is not Walgreens' strength when it comes to pricing, the service is offered for 19 cents per 4 × 6–inch photo, about $2 for a 5 × 7–inch shot and about $4 for an 8 × 10.

RitzPix.com

The digital photo development site of the Wolf Camera and Ritz Camera stores (which share the same owner), RitzPix offers 19-cent 4 × 6 prints by mail and charges about $1 for 5 × 7 shots and about $4 for 8 × 10s.

INDEPENDENTLY OWNED RETAILERS' SITES

In addition to the big boys, most of the independent photo stores who are still in business have made it because of an easy-to-use online presence that has allowed them to receive orders from around the country. Use the lab finder at TakeGreatPictures.com (detailed in this chapter on page 65) to find the independent photo labs in your area.

Of all your possible photo printing providers, these independents are the ones most interested in building a personal relationship. Like most mom-and-pops, their store's success and the owner's family's livelihood depend on your satisfaction with their quality and service. You might prefer to deal with local stores, but if you're uploading your photos and receiving prints by mail, it does not matter where the retailer is located. Even Mary Beth, who used an independent photo retailer located across the country from her home was able to get hand-holding customer service; the owner of 30 Minute Photos Etc. answered her questions on the phone.

A WORD ON SHIPPING COSTS

The prices discussed in this section do *not* include shipping costs. Typically, these run between $1 and $5 per order of up to about 50 prints and increase incrementally from there. Remember to add these fees onto your estimated calculations for mail-order print costs.

OPTION 3: UPLOADING IMAGES TO A LOCAL PHOTO LAB AND PICKING UP PHOTOS

Today, nearly all of the bigger photo lab chains, including the ones described above, offer a convenient option for you to get great photos: You can upload your digital photo files online and pick them up at the store nearest you, often within an hour! Stores such as Wal-Mart, Walgreens, and Ritz/Wolf Camera—stores with multiple locations that likely have at least one outlet near you—have this service available on their Web sites. Many independent local retailers also provide it. It's a great way to eliminate the drop-off trip to the store: You make a virtual drop-off online, choose the location where you'd like to pick up, and then pick up your pictures at your convenience. The Web site simply directs your files to the store of your choice, and you get a notification e-mail when they're finished.

Today, the cost per print for in-store pickup is a bit more than it is for pictures you have mailed home because of the routing that's required and, for those that offer it, the one-hour guarantee.

WHICH RETAIL OPTION IS BEST?

I've used each of these retail-based options many times. The third option is convenient and effective—but only if you have a reasonable number of pictures to upload. At home, I have an average consumer high-speed DSL Internet connection, and I use a 5-megapixel digital camera that captures photos about 2.2 megabytes in size. That means it takes about a minute, on average, for me to upload each photo. This is convenient if I need 10 quick prints, or maybe even 24 of them. But if I'm printing 100 pictures from a long weekend, or worse, 300 pictures from an extended vacation, it will simply take too long to transmit all those files. The "upload and pick up" option is best for a limited number of pictures.

The same is true for the "upload and delivery" option, since the time you need to transmit your photo files remains high. It's a great convenience if you're printing the digital equivalent of a roll or two at a time. Any more shots, and it's faster to just bring your digital pictures in. We're used to dropping our film off. It's how we developed our pictures for half a century. Today, we can do the same with our digital photos. And for me, given the speed, convenience, and affordable pricing, bringing in my digital photos for printing and picking them up—many times within 60 minutes (and if there are only a few prints to be made, before I even leave the store)—is the most convenient option.

But there is one last option for having prints made of your pictures. It also results in terrific-looking snapshots, and it has nothing to do with photofinishing labs.

OPTION 4: MAKING PRINTS AT HOME

Now that you know all about the digital version of getting prints made the old-fashioned way, at the store, let's talk about printing your shots at home. Over the last several years, as discussed on pages 31–34, the quality of home photo printers has skyrocketed while prices have fallen. Today, we can make print photos at home, hold them next to shots developed at the store (from film or digital cameras), and not tell the difference between the two.

Consider Joe's story: He's an aspiring photographer with two daughters, and to hone his craft, he recently invested about $1,000 in a high-end Canon 6-megapixel SLR digital camera. It's a full-featured camera. Joe can change the lenses, attach various flashes, and manually control nearly every photographic variable for what he shoots (which is, quite often, his daughters).

Along with the camera, he invested about $150 for a full-size desktop Canon inkjet photo printer. When he saw the first prints, he couldn't believe his eyes.

"I was just thrilled," Joe says. "I thought, Holy cow, this is great. I couldn't believe the quality. I couldn't tell the difference between lab prints and these prints."

Most of today's photo printers are inkjets, the same printer technology we had in the 1980s when Hewlett-Packard came out with the first widely available color printer for consumers. Only back then, inkjets only had two ink cartridges inside: One was for black, and the other was for color. All color. These were great printers—in the 1980s and early 1990s. Today's printers are a bit different. Many have six ink cartridges, and some even eight (including one for the glossy finish that coats a printed piece of photo paper). With all these ink cartridges, each specializing in applying its own specific color, it's easy to understand why the photos look so good.

HERE TOO, NO PC REQUIRED

Many people are surprised to hear this, but you can use a digital camera and print fabulous, bright, great-looking photographs on a home printer . . . without a computer. Many of today's newer printers can be hooked up directly to a digital camera via a USB cable and print right from the camera! Look for printers and digital cameras that are labeled as being "PictBridge compatible." That's the easy-to-say standard the industry developed for communications between cameras and printers. If your digital camera and photo printer are both PictBridge compatible, you can connect them together and print pictures.

Also, nearly all small snapshot printers accept memory cards directly, so you can pop the card out of your camera, slide it into the printer, and make pictures. A lot of these units also have 2- or 3-inch LCD screens so you can see what you're printing. The ones that don't include an LCD screen make "index prints," which have

thumbnail images of all the pictures on the memory card. From these index prints, you can select the ones you want to output.

SMALL, LARGE, OR SUPERSIZE: THE PHOTOS LOOK GREAT

No matter which of the printer types you use (small snapshot printers, larger desktop printers, and supersize printers are all discussed in detail in Chapter 2), your homemade prints will look fantastic.

Says Joe: "The prints that come out of the printer are exactly what I want and how I want. What I see on my screen after I'm done with the manipulation, that's what comes out of the printer." He's comparing these to store-made photo prints, which are outside of his—and your—control. Pictures might be automatically cropped to fit a certain size print, as discussed in the beginning of this chapter.

With your home printer, photos are printed to cover the entire surface of the paper, and there's no paper-cutting required. You purchase the paper size you want (it's widely available in 4 × 6–inch, 5 × 7–inch, and 8 × 10–inch sizes) and adjust the printer's paper tray to accept the size you choose.

Here is some fine-tuning advice for printing at home:

Should Your Printer Be Manufactured By the Same Company That Makes Your Camera?

Many experts believe that you'll get better looking pictures if your printer is manufactured by the same company as your camera. That's why Joe bought a Canon printer. "I got a Canon printer because of my Canon camera," he says. "I think it makes a difference."

And, understandably, Canon agrees. Here's what the company's senior marketing manager has to say on this matter: "There's a lot of back-end work we do to connect our cameras with our printers, whether it's as simple as [adjusting] the color tables or adding extra functionality when you connect our camera to our printer [so] the camera understands more."

This could be true, and there's probably no way to prove it to us consumers, but in my extensive testing, I've seen printers from lesser known manufacturers do fantastic work with digital photo files made by all kinds of different cameras. Epson photo printers make fabulous prints of digital pictures whether they've been captured with a Kodak, a Sony, or a Fuji digital camera. I recommend buying the camera you like best, and then buying the printer you like best, without worrying about their being the same brand.

But You Should Buy Photo Paper
Made by Your Printer's Manufacturer

Indeed, companies do a lot of work on the chemistry behind how the ink in their printer cartridges marries, or binds, to their own photo paper. Thus, a Hewlett-Packard photo printer makes a noticeably better looking picture on its own paper than it does on a competing brand's product. And on generic photo paper sold in bulk at discount stores, your pictures will look even worse. So it will be worth your while to invest a bit more in high-quality photo paper made by your printer's manufacturer. You'll simply have better pictures. (This is an easy test to conduct yourself: Purchase paper made by your printer's manufacturer, along with one or two other brands of photos paper. See which one produces better-looking prints.)

REMEMBER THE COST OF INK AND PAPER

As long as we're talking about ink and paper for your photo printer, don't forget about the cost of supplies here. For smaller photo printers that make snapshots 4 × 6 inches or smaller, you can typically purchase an ink–paper package that provides the cartridges and photo paper in a single box. On average, these cost around $20 for 50 pictures.

Further, larger multicartridge printers need individually purchased color cartridge replacements. These usually go for about $10 each—but this can add up quickly if your printer has eight different cartridges. For larger printers, paper is sold separately in a variety of sizes.

At this point, with retail prices so low, it is more expensive to print at home than it is to print at retail. But printer manufacturers such as Epson and Hewlett-Packard are working hard to catch up and make their prices competitive with photo labs'. But you're paying for the convenience of great-looking prints without moving from your office chair.

WHEN TO PRINT AT HOME; WHEN TO PRINT AT RETAIL

Home printing and retail printing are not mutually exclusive. I use both: If I have only a few prints to make, I do it at home. Also, if I want to make a bigger print, for framing or for my wife's scrapbook, I do it at home. But I find that it's just too time-consuming, labor-intensive, and, at a certain point, cost-prohibitive to make large volumes of snapshot prints at home. You have to change the paper. You have to make sure there's enough ink in all the cartridges. If you walk away from the printer and the cyan cartridge runs out of ink in the middle of the job, you have to reprint, using the other inks two times over. Of course, the printer software warns you when the inks are running low, and for many people printing

pictures at home is a completely suitable option. For me, it's great when I need a few shots printed. But when it comes to a volume of prints, that gets done at retail. I drop the photos off and go run an errand or two, and when I come back, they're waiting for me.

HOW LONG DO THESE PICTURES LAST?

Great question! How did you know to ask that?

This is a common concern, of course. And there's good news. Today's photo printing technology makes photographs with durability that's measured in decades, not years. Many of the newer home printers are designed to make pictures that will last for over a hundred years before fading! This is longer than pictures made at some professional photo labs.

There's a respected organization that measures and tracks how long photos from consumer printers will last before fading. It's called Wilhelm Imaging Research, and much of its data is available for free at its Web site, www.wilhelm-research.com. If durability is a concern for you, take a quick look here before buying your photo printer. But overall, I agree with Joe, who says that if the photos fade, "I've got the original digital files. I'll just make more prints."

Indeed, digital photo files don't fade. Ah, the joys of going digital.

THE BIG PICTURE: PRINTING PHOTOS

To sum up:

- There are four major options for printing your digital pictures:
 1. Drop off and pick up your pictures at retail
 2. Upload your files to retail and have prints delivered to your home

3. Upload your files to retail and pick up prints in person

4. Print pictures at home

- For large volumes of pictures, printing at a photo lab is more affordable and requires less of your time and attention.
- When printing at home, use high-quality paper made by the same manufacturer as your printer.
- Whether you want to print at home or at the store, no computer is required. It's helpful but not necessary for enjoying high-end digital prints.

SHARING DIGITAL MEMORIES
How to Enjoy Your Photos and Videos with Family and Friends

This chapter is probably my favorite, as it deals with the easy, affordable, heartwarming ways you can share your digital pictures and home movies with your loved ones. From simple digital photo albums to more complex online photo sharing sites, from Internet-enabled digital picture frames that play photo slide shows to combining your home movies and photographs on DVD, nearly all of these exciting possibilities require tools that are either free or surprisingly affordable. There's little presented in this chapter that costs more than $50.

The increased ability to share your life's moments is one of the greatest advantages digital photography and video enjoy over their distant analog cousins. Throughout this chapter and the next, you'll read the inspiring stories of how real people use widely available tech tools to share their memories. If they can do it—and this is a fact—you can too.

PHOTO ALBUMS ON CD

Meet 81-Year-Old John

"Hello, Alex!" roars 81-year-old John as I walk into his study in suburban Chicago. "How the heck are ya?"

John recently celebrated his fiftieth wedding anniversary with his wife, Pat. It was about the time that they married—1955 to be exact—that John took his very first film photo. He's big (at about 6 feet 5 inches, he dwarfs his com-

81-year-old John

puter stand, even while sitting) and exuberant and he loves two things more than anything else: his family and his technology. He's so good with the latter that he teaches computer classes for seniors several times each week. So lately, he has combined his two passions. At his Windows-based PC, John is usually involved with one project or another having to do with his family.

"Family has been our whole life," he says. "Oh my God! I'm so lucky. I have so many relations, and I love seeing all of them." John has six children and countless cousins around the United States.

I've come to see what he's working on.

"Looky here." He motions me over. "This is a spiffy doggone little program."

He's clicking around in a program called Diji Album, a $40 downloadable software most people have probably never heard of. "This is the best little program out there," he says.

He clicks the mouse and up comes what looks like the cover of a photo album. It reads: "Norbert & Rita's 50th Wedding Anniversary." It's a photographic tribute John put together for his brother's golden anniversary. He clicks on the cover. There's a welcome page from John, all text, telling people who have received this album on CD-ROM (he has sent out more than 50 copies) how to use it and what's inside. Click. More text. This time a family tree he has put together appears on the screen, listing all of Norbert and Rita's known family members. Click. The page turns. Finally, the photos. But they're not photos from an anniversary party. They're old photos, some more than 100 years old. They're pictures of a young Norbert and Rita, their par-

ents, their family. They're photos John and his wife have scanned into their PC. Some have one photo per "page," others have two, three, four. Almost all of the pictures have text captions. There's a graphic of a spiral binding running down the side of the screen. The whole experience feels like you're flipping pages through a photo album.

"The beauty of this thing is it looks like the same kind of photo album your mom or grandma would make out of paper, except it's digital and it won't fade," John says. "It's very, very easy to make an album and put it on a CD, and you can give it to anybody. They put it in their computer and it starts up right away."

That's beautiful music to my ears.

"I can position the pictures anywhere on the page, I can size them any way I want, and I can crop them too." A limited word processor is also included, where you can write introductions to your albums, or add stories between the "pages." John also used the word processor to create the family tree (more on John's epic family tree work in the next chapter).

John can also pop the photo album CD into his DVD player in the family room, which is capable of playing graphics files (many DVD players manufactured after 2003 have this capability). "I bought that thing for $59," he proclaims proudly.

How many CDs has he made with this program?

"Oh my Lord, I don't know. Probably hundreds. I have all kinds of cousins and so on."

Why does he do it?

"It's family history!" he exclaims immediately. "What I tell my students all the time at the senior center is that we're living history. I don't care what we're doing, we ought to be scanning photos, doing family tree work, and writing our autobiographies. When we're gone, this stuff gets a lot harder to find."

Let's pause here a moment. Read John's last sentence once more. Let it sink in. Think about what he's saying.

"Family is my whole life," he says. "And I want to pass on as much as I can. This technology makes that so easy."

John and Pat have scanned thousands of old photos. This photo album

contains more than 250 photographs from Norbert and Rita's lives. He has made more than 10 of these kinds of albums using the $40 Diji Album program. He has sent his family members hundreds of CDs filled with these photo albums. And, in doing so, 81-year-old John has brought priceless memories and, almost always, tears of joy to the eyes of his family.

"It means a lot to me. I send them out to all kinds of relations. They love it. I love it."

And *that,* dear readers, is what going digital is all about. Using the tools that make sense for you to share your photographs—new ones, very old ones, and all the ones in between—your movies, and your memories with your family and friends. Online and offline, at the computer and in the living room, it's all about sharing the memories of your life.

John's story is just one of many ways to share your digital photos and movies. In this chapter, I'll cover a wide range of ways you can do this.

John has plenty more lessons for you, and you'll read more about his story in chapter 6. Until then, here are the details on the simple programs that can create digital photo albums on CD-ROM.

DIGITAL PHOTO ALBUMS

Here are three examples of the kinds of digital photo albums that can be created. From Diji's photo albums to PhotoParade's slide shows and Photo Story's picture videos, you can do a lot with your pictures for very little cost. All three of these tools are available for download and immediate use.

Diji Album About $40 · www.xequte.com

The closest thing to a digital version of paper photo albums, complete with cover designs and "flippable" pages, Diji Album lets you lay out pages with not only photos and text but with

sound and video as well. Which means you can add verbal descriptions of the photos you're presenting. What could be more exciting than that? You can add short movies onto the pages as well. So picture it: On one page, you can have some pictures and audio explanations of Johnny's birthday, and on the next page, you can have a two-minute movie of it. In addition to placing the photo albums onto CD-ROMs, Diji also lets you publish your entire album onto the Internet, if you're interested in sharing your albums online. Diji is for Windows-based PCs only.

PhotoParade Essentials About $25 · www.photoparade.com
PhotoParade is small program that lets you create slide shows with your favorite pictures. For example, you can use this program to create a slide show of a recent family dinner. You can add a title screen along with text captions to the photos and place the whole thing onto CD-ROM for distribution to the attendees. Best of all: This can all be done before anybody leaves, so everyone has an instant memento of the event. The slide show CD, like the program, plays on Windows PCs only.

Photo Story Free · www.microsoft.com/windowsxp/using/
digitalphotography/photostory/default.mspx
Even Microsoft has become involved in doing neat things with digital photos. Its product, Photo Story, is available as a free download at the rather lengthy Web address above. Its claim to fame is creating video files with your photographs that include special effects "camera movements" over your pictures (called pans and zooms, or, in more technical lingo, Ken Burns effects; he invented them, apparently). You can also add transitions between photos, voice narration, and a musical soundtrack, creating a high-end digital slide show for your computer. You can copy your slide show as a movie file onto a CD-ROM and distribute to friends, who can play it on Windows or Macintosh computers. It's quite a useful tool, and it's free. What more can you ask?

PHOTOS IN A BINDER, PHOTOS ON CD

Consider my father-in-law Ron's example for a relatively low tech approach to sharing images. No matter the event, the entire family knows he's the chief photographer and will capture the day and its people with his digital camera. Everyone also knows they'll get a nice binder from Ron soon after the event. The binder features printed index pages with thumbnail, or small, versions of all the pictures he took. Under each thumbnail is the file name of the picture displayed. Following the index of pictures, Ron's favorites are typically printed as 4 × 6–inch shots, about two to a page. In the pocket of the binder is a CD-ROM with the original digital photo files.

With such a practical "catalog" binder, people are able to select their favorite snapshots on paper and cross-reference the file name to the CD-ROM, where they quickly access the file for editing, on-line sharing, and/or printing.

How does Ron create thumbnail versions of his full-size photographs? He uses a program called Epson Film Factory, which came free with his printer and is available for purchase online. It has a menu option for creating a thumbnail Web page of any photographs he selects. Once the Web page is created, he prints it, and it's finished.

In addition to Epson Film Factory, there are a few small programs available as free downloads that are designed to create thumbnail versions of full-size photographs. These tools assume that you want to create a Web site with your photos, as the thumbnail galleries are created as Web pages. For our purposes, we'll simply print the index pages it creates. There's no need to publish them to the Internet, as there is a wide selection of easy-to-use photo-sharing Web sites for this (more on photo-sharing sites later in this chapter).

Epson Film Factory About $30 · www.epson.com
(type "Film Factory" into the search box)
> Included free with many of Epson's photo printers, this tool is a photo organizer as well as a basic photo editor. It's available as a free 30-day download for both Windows and Macintosh platforms and creates thumbnail Web pages, which can be printed for sharing with a CD.

EZ Thumbnail Builder Free · www.esmarttools.com
> This tool, which operates on Windows-based PCs, creates thumbnail galleries, also as Web pages, for publication to the Internet. Don't publish (we'll use photo-sharing Web sites, discussed later in this chapter). Just hit Print.

Easy Thumbnails Free · www.fookes.com/ezthumbs/
> This is another free program that creates thumbnail sets from your digital photo files that you can print as catalogs.

PHOTOS ON TV, WITHOUT A PC

You've already read about several ways to enjoy going digital without a computer. Here is one of the better examples I've come across:

Don is a veterinarian. At 59, he loves digital photography but hates computers, so he doesn't have a computer at home. But he does use a Canon PowerShot digital camera as his primary photo camera. Here's how he does it:

Don takes far more photos with his digital camera than he ever did with a traditional film camera. He keeps the ones he likes and quickly deletes the ones that aren't up to his standards. How does he view the photos? On TV. "I come home, put the memory card into the machine, and my wife and I view our pictures on TV. It's a nice thing for somebody who's not very computer literate," Don says.

The "machine" is a Digital Photo Viewer made by a company called SanDisk, which is one of the top makers of memory cards. Connected to his television with a yellow video cable, it's a small plastic box that has a variety of slots for all different memory cards that are currently on the market. So Don is able to pop his camera's memory card into the corresponding slot and watch a slide show of his pictures.

Don also uses a snapshot photo printer at home that accepts his memory card for making prints at home. Of course, he can also take his digital pictures to a retail photo lab, get all the prints and enlargements he wants, and have CD-ROMs created for backup.

Who says you need a computer?

HOW TO VIEW YOUR PICTURES ON TV

Here are some more details on photo viewers that let you watch your pictures on TV:

SanDisk About $50 · www.sandisk.com

This device accepts eight different types of memory cards, along with the popular USB flash memory sticks (the kind that are often made to be key chains; they plug into your computer's USB port and are convenient for quickly moving files from one PC to another). This little unit can also play movie files; plus, it connects to your stereo system to play MP3 music files that you might store on your memory card.

STRAIGHT FROM YOUR DIGITAL CAMERA

Many cameras have a yellow "video out" connection. Just plug a yellow video cable between your camera and your television and start a slide show from your camera's menu system. This is convenient and quick and costs nothing. It's also a great way to do some basic editing (most cameras can crop photos and convert them to black-and-white, among other editing capabilities) on a large television screen instead of the small LCD screen on your camera.

CONNECT YOUR PHOTO PRINTER TO YOUR TV

A lot of the portable snapshot printers that accept memory cards— and even the ones that connect directly to your digital camera with a USB cable (see details on these printers in chapter 4)—also have a video out plug that connects right to your TV. This is also convenient for previewing photos on your big screen and for doing some of the basic editing functions that many snapshot printers have built in.

THE MAGICAL DIGITAL PICTURE FRAME

Like all grandmothers, Shirley loves getting pictures. She has children and grandchildren, nieces and nephews, even grandnieces and -nephews. And once a week, sometimes more, Shirley's daughter, Joyce, sends her pictures of the family.

"I'm the keeper of the family photos," says Joyce, 58. "Most of the family members send me pictures, and I'm in charge of getting them to Mom." And so Joyce receives the pictures, sorts through them, and sends them along to her 87-year-old mom.

And as you've probably already guessed, the pictures don't go to Shirley as printed photos, through the mail. Instead, they land squarely on her digital picture frame, where they play as a slide show, rotating until Joyce sends the next update.

You see, Shirley received a CEIVA Digital Photo Receiver for her eighty-fifth birthday. It consists of a 5 × 7–inch LCD screen, surrounded by a wood frame. It plugs into an electrical outlet for power and a regular phone line for receiving pictures. Then, like a TiVo video recorder, in the middle of every night, the CEIVA "frame" dials in to check for photo updates. Any new photos are downloaded, replacing older ones. The CEIVA receiver can store 30 pictures at once on its internal memory.

How does the frame know which pictures to download? Good question! It gets only pictures that you upload. Joyce uploads the photos she wants to share with her mom to CEIVA's Web site, which she logs in to with a password, and then every night, the frame checks for and downloads any pictures. Anyone who knows the password can add pictures to Shirley's frame, which means she can get pictures from various family members from all over the country.

"Every morning, Mom goes downstairs and checks the CEIVA first thing," Joyce explains. "And she says, 'Oh my! There are new pictures!' And she calls Joyce at 7 AM."

This is an ingenious, effective, and incredibly rewarding way to share your pictures with the nontechnical family and friends in your life. No computer is required. No high-speed Internet connection is needed. Just an electrical outlet and a phone jack.

"My mom is terrified of technology," Joyce says. "If she sits on her TV remote, we're all in trouble. We know we'll need to take a 40-mile trip to her house just to push a couple buttons."

Often Joyce adds text to her pictures, explaining details such as dates and locations. These annotations can be added right on the CEIVA Web site, next to each photo. She also uses the frame to send her mom digital holiday cards. Joyce calls herself an "exhibiting amateur photographer" and uses her favorite artistic shots in the cards she sends to her mom's frame.

Joyce also uses the digital picture frame as a means of sharing day-to-day events and activities with her mom: "For example, I got a new piano recently and I didn't know when Mom would be able to make it over to the house, so I took a picture of the piano and I sent it to her frame. This way, instead of just telling her about it, I can show her."

All of this leads to the ultimate bottom line for any kind of digital tool: It makes Shirley happy. "Oh! There's nothing like it for her. This is an absolute proven joy gift. It's ensured happiness."

❖ ❖ ❖

Recently, my family traveled together on a 10-day European cruise. There were six of us—my wife and I, my parents, and her parents. My Grandma Bella, who is 79 years old, did not come along. But she felt like she did, because before I left, I set up a CEIVA digital picture frame for her. And every day, using a laptop with a wireless Internet connection, right on the ship, we uploaded that day's pictures. They arrived on the digital picture frame on Grandma's bedroom dresser. We felt great doing it, she absolutely loved seeing a real-time visual diary of our vacation (often insisting that neighbors

come look, to show off), and, as is usually the case when digital technology is applied effectively, we were all very happy.

Here are some more details on digital picture frames.

CEIVA Digital Photo Reciever
About $70 · www.Ceiva.com

The 5 × 7–inch frame, at the time of this writing, cost about $70 after a rebate. A service agreement is also required, which is sold for about $10 per month, annually for about $100 ($8.33 per month), or on a three-year plan for $250 ($6.95 per month). The frames and mattes are interchangeable, so you can dress your digital picture frame up for different rooms. Black and silver frames are included. Frame packs are also available for about $13 each. They include one frame in one of the following colors: cherry, maple, walnut, mahogany, and silverstone grey. You can also pick from a matte that's black, sage, oatmeal, or off-white.

AVtech Solutions Digital Picture Frame with Remote About $160 · www.avtechsolutions.com/vdpf2.htm

About the same size as the CEIVA frame, the AVtech device is a more modern-looking, metallic frame with a remote control included. In some aspects, this unit does more than the CEIVA device: For example, it plays pictures, video, and MP3 music files. It also has a "video out" jack that connects it to your television, which can display all of the items the frame is showing. But this frame is fundamentally different than CEIVA's. It does not connect to the Internet for its photos and movies. Rather, it accepts memory cards, where the information must be stored. As such, it does not have the remote option of "sending Grandma photos," but it's a fine device (albeit a more technical one) for en-

joying your own pictures, movies, and music away from the computer.

PhotoVu Digital Picture Frame About $800 · www.photovu.com
On the high-tech, high-end of digital picture frames are PhotoVu products. They're large, at 17 and 19 inches diagonally, and they're wireless, which means they don't have to be connected to a phone line—or have to any Internet connection, for that matter. You can transfer photos from any Internet connection. But these frames, while large and quite good looking, are for the technically savvy. They can support, for example, an additional 40-gigabyte external hard drive for storing thousands of photos. And you can choose from 29 different transitions, such as fades between pictures.

SHARING PICTURES ONLINE

When business brought Mark and Laurie to the Chicago area from their home town of Minneapolis, they found themselves away from their family for the first time. Although they phoned and e-mailed their parents and siblings often—and even visited several times each year—they found it hard to be so far away. And when they had their first baby, Max, things got even more challenging.

"It's so hard for us being transplants," says Laurie. "It's been hard for them not to be involved. This is only my parents' second grandchild, and they're very sad they're not around the corner. We sometimes feel like we're on an island without any family."

So they went looking for an easy, affordable way to share their lives, and more importantly, Max's life, with their families. They came across a Web site called SmugMug.com, which lets users post their digital pictures and home videos. They paid $30 for a one-year subscription to SmugMug. They created various galleries, or albums, such as family, friends, and party, and, at first, they posted new pictures every day.

Web sites such as SmugMug make it easy to set up your own photo-sharing site. There's no Web design work involved. All you do is name your galleries and upload your photos. You can also add text captions for each picture ("Max loving the swings!"). All the photos you upload are automatically converted to three different sizes: small, medium, and large. Viewers get to pick the size they want to see for each picture. These additional photo viewing options are a result of SmugMug's being a photo-sharing site first and foremost. (Many of the better-known photo Web sites are designed around selling prints of the pictures.) SmugMug also offers prints as an option, but its bread and butter is seamless, easy picture sharing.

"I was getting constant requests from Max's grandparents," says Laurie. "They just couldn't get enough." The grandparents would point their Internet

Mark, Laurie, and Max

browser to Mark and Laurie's personal Smug-Mug Web address and immediately view the photos, sometimes only moments after they were taken. Mark and Laurie chose not use a password, although it is an option.

"This has really helped them stay in touch and to feel like they're a part of Max's life," Laurie says. "And they can watch him grow. They look constantly on their own, and we'll send them e-mail updates about how many inches tall he is and include a link to the pictures. It has made a world of difference for us."

NOT JUST FOR FAR-FLUNG FAMILY

Interestingly, and somewhat unexpectedly, Mark and Laurie discovered that a lot of people besides their parents were checking into their oft-updated picture sharing site. For one, many of their friends logged on periodically, even those who live nearby. In fact, people attending the same barbecues and birthday parties as the family ended up visiting the site to download and print photos of their own kids. This happens most often with parents of children in Max's playgroup.

"Whenever I'm with Max's little friends, I'll snap pictures and put the photos up on our site," Laurie says. Then she adds something most moms can relate to: "That's the focus of our life right now. I'm with Max and his friends and their moms three times per week. I love taking pictures of everybody. People say, 'Thank God for Mark and Laurie, because they're documenting my own kid's life.'"

Which means this: You can download photos from your friends' and family's photo-sharing sites and add them to your own collection of pictures. A group of people snapping digital pictures at the same event makes for a unique opportunity to gather multiple perspectives, angles, etc. And if the group shares their shots online, you can collect the pictures you want, at your convenience, without taking anybody else's time. Of course, the same thing can be accomplished by e-mailing photos back and forth—and it often is done this way—but posting pictures online allows for "always on, never bother anyone" sharing.

Finally, photo-sharing sites are great if your family is not nearby. But I can tell you from my own family's experience, sharing pictures this way is highly rewarding even if everyone lives nearby—or right down the street, for that matter. Wherever you live, there's something magical about opening up a Web browser and seeing pictures from the family dinner last weekend or the

family vacation last year. It's memories on demand, whenever you want them.

PHOTO-SHARING SITES

Of the various types of going digital Web sites, the photo-sharing category is the most populated. There's a wide range of effective, full-featured, mostly free photo-sharing Web sites just waiting for you to use them.

SmugMug www.smugmug.com

Unlike most other photo sharing sites, SmugMug is designed for sharing first and everything else (including printing) second. As such, unlike the others, it's not free. That's because other sites, including the ones below, offer photo-sharing services as an entrée to printing. SmugMug does the opposite, making sharing the primary service offering. Don't worry, though. The price is small: About $30 buys you a year of using its Web site for photographs only. And if you want to share small videos as well, the price goes up to $50 per year. Photos are displayed in a variety of sizes: small, medium, large, and the biggest: "original." You can caption every picture and password-protect only the galleries you deem necessary (your whole site need not be password protected). Finally, you get a Web address here, and anyone who knows your site's address can visit anytime. Most other sharing sites are "invitation only," where e-mails are sent that have links to shared pictures. (You know the ones: "Hey! I've posted new photos. Click here to see them.")

Flikr www.flikr.com

Like SmugMug, Flikr is a true photo-sharing site, designed first and foremost to let others see your pictures. In addition to organizing your photos into albums, you can add keywords for each picture and search for them by keyword as well. This way, if

you want to find all of your "birthday party" photos, just search for that term and you'll get all the photos that match. A twist on Flikr: There's a community, bloglike (see chapter 7) aspect to this Web site. Anyone, from those whom you invite to strangers who stumble across your galleries, can add comments to your pictures. And, to be fair, you can comment on everyone else's photos too.

Kodak EasyShare Gallery www.kodakgallery.com

Among the large online photo sites, the Kodak EasyShare Gallery is closest to a 50-50 emphasis on sharing and printing when it comes to features and functions. You can upload your photos, organize them into albums, share them online, and then order prints when you're ready. If you're going to be ordering your online prints here, it probably makes sense to take advantage of the free sharing functionality as well.

Snapfish www.snapfish.com

Log on to Snapfish.com, and you'll see a clear emphasis on printing pictures. In fact, this site leads with a free prints offer, and then discusses free online photo sharing. The photo-sharing portion on here is free but scaled back in features when compared with SmugMug. You upload your photos and organize them into albums, which can be shared via e-mail invitations. At a low cost of 12 cents per 4 × 6–inch snapshot, you may want to share your pictures here as well.

Yahoo Photo http://photos.yahoo.com

Yahoo's photo service offers print delivery by mail, or you can pick up your uploaded pictures at Target stores. The site also allows for sharing photos, but only through e-mailed links. It is not possible to visit your albums via a Web site. Only people you invite via e-mails sent through Yahoo can see the albums you put together.

Shutterfly www.shutterfly.com

Like the other print-first sites, Shutterfly wants you to make snapshots with your photos and offers the sharing option so that you, along with friends and family whom you invite to view albums, will purchase picture prints.

MAKING FABULOUS PHOTO SLIDE SHOWS SET TO MUSIC ON DVD

The Gift: A Tribute

Gregory's seventieth birthday party was an affair to remember. The food and drink were excellent, and the toasts were plentiful. He got more presents than he could count. But the greatest gift was one that was shared by Gregory and all his guests. For 15 minutes, the entire party sat with eyes glued to a 20-foot big-screen. The gift played on an LCD projector that was connected to a DVD player.

What was everybody watching? It was a photographic and video tribute to Gregory's life, put together by his nephew, Andy. There were more than 300 pictures from Gregory's life, as well as images from the lives of his family and closest friends, many of whom watched the completed product together with him. Many of the pictures were as old as Gregory.

Andy scanned them using a $200 Epson scanner and his Apple Macintosh computer. Then he used the Adobe Photoshop Elements program, which was included free with his scanner, to touch up every picture. He cropped some of the photos and adjusted the color on others. Once they were scanned and edited, Andy turned to Apple's iLife suite of multimedia applications (discussed in chapter 2).

He stored and organized the scanned pictures in iPhoto. And he arranged them, in order, in iMovie, which is Apple's movie-editing software. He dragged the pictures onto the movie timeline and added transitions between the pictures. He indicated how long he wanted each picture to be displayed during the slide show. And he also added panning and zooming effects across the photos, as though a video camera were moving over the pictures.

Next, Andy brought in the movie clips he had shot for this project. Using a Sony digital camcorder, he interviewed a number of family members. This footage contained heartwarming stories and remembrances from the people closest to Gregory. It was interspersed between the photos. From the photos to the video, everything was molded for "people to get a feel for how much he has affected their lives," Andy says. "I wanted it to be sentimental and funny. I wanted to show the times of his life."

When the visual portion of the show was finished, Andy added a soundtrack to the iMovie file. In addition to voice-over recordings that were captured with his computer's built-in microphone, he dragged music files into the movie. "They're all old songs from my uncle's life," Andy says. He created the DVD using another application in the iLife suite: iDVD. This is the program Andy used to make the opening menu screen and create copies of the DVDs.

Every guest at the party received a DVD to take home. What a spectacular, deeply meaningful gift! Then, 30-year-old Andy remarked: "People will have these DVDs at home with them for their kids and their grandkids. There will always be a record of this man's life. I think it's something we all want to do, to leave a record for the next generation."

This insightful thought is what going digital is all about. Photographs were never meant to sit unseen on your computer's hard drive. They ended up there because of a perfect storm of lightning-fast technological development and cold, confusing tech speak. Your pictures are on your hard drive because the technology industry did a great job of marketing great technology and a terrible job of teaching you how to use it in meaningful ways.

EMOTIONAL IN EVERY SENSE

As I worked on my own DVD slide show for my father-in-law's surprise birthday party, using the same software and following a process similar to Andy's, it occurred to me that these slide shows—set to music—activate emotions on several levels:

Visually, we see old pictures from our family's lives not in small handheld snapshots but on large televisions. We see our fathers and our mothers, our aunts and our uncles as they were before they assumed these familial titles. We see them as children, in another time. We see them, perhaps, as we have never known them.

Then, while we're watching these images pass before us on the screen, we're hearing carefully selected "mood music" that activates our emotions on a auditory level. For example, on the DVD I put together for Ron, I chose songs that closely matched the menu choices and themes on the disc (the choices included *Young Ron*, *Happy Ron*, and *Family Ron*). Not only that, but I even tried to time the arrangement of photographs with a song's lyrics, so that certain pictures would correspond with certain words in the song.

And while we're being stimulated visually and aurally, we're experiencing emotional thoughts and memories about the subject of the show. All this, put together, results in a very emotional experience. Many people have never had the opportunity to see photos in this way before. In fact, every time I have presented one of these slide shows set to music, nearly everyone in attendance has expressed appreciation and gratitude—even if their photos were not in the piece. The point: It's an amazing way to look at pictures—a way that most people have never experienced before. And it's very, very rewarding.

IT'S ABOUT THE PROCESS

Something else happens every time I work on a slide show DVD: I find myself tearing up while sitting in front of the computer, watching the slide show for the nineteenth time, trying to time the photos to the lyrics in the music. (This process is less technical than it sounds in most consumer software; it's trial and error. I drag pictures around and hope they coincide with the words I want. If it's off a bit, I adjust until I get it right. This is, of course,

not necessary—and it's much more exact in higher-end, more expensive programs such as Final Cut Pro for the Mac and Adobe Premiere for Windows PCs.) I've already seen the presentation countless times. Heck, I scanned the pictures! But every time, without fail, I sit there by myself in front of my computer monitor, with pictures and music playing, and I get emotional. I think about how lucky I am. I think about what my family has gone through to get me here today.

You may not think the same things I do, but chances are that if you're taking the time to work on a project like this, family is very important to you. And you will think about how important and valuable your family is to you. Or how great your dad looked when he was young. And how great he looks now. Those are the kinds of things that go through your mind when you're working on this kind of project.

And just wait until people actually see it.

WHAT YOU NEED TO MAKE YOUR PHOTO SLIDE SHOW DVDS

As discussed in chapter 2, to make these kinds of presentations yourself, you'll need a computer with a DVD burner for obvious reasons. You'll probably want a scanner to digitize old pictures to include them in your slide shows. And you'll need a program that can create slide shows on DVD. Options for Windows PCs include Belkin Hi-Speed USB 2.0 DVD Creator, Pinnacle Studio Plus, and Adobe Premiere Elements. For Macintosh computers, it's easy. Use iLife. It comes installed on new machines and can be purchased for about $80 if you don't have it.

Are these projects easy to create? Yes. In most programs it's this easy: You lay out your photographs on a timeline in the order you wish them to appear. On an adjoining timeline, you lay out the songs you'd like to play. Then you play the sequence, make adjust-

ments if you wish, add transitions such as fades between pictures, and when you're satisfied, click Render so that your PC can make a movie out of the photographic and musical parts you've put together. Once that's done, you can lay out your DVD menu if you want. This involves selecting a template and music and positioning the menu choices where you want them on the screen. Once this is finished, tell the program to burn the whole thing onto a DVD, and, in an hour or three (depending on how many photos you have), it's done.

And, as you've seen, they're incredibly rewarding. But there are elements, such as scanning and touching up many old photographs, that are rather time consuming. If you don't want to invest this time—or if you simply do not have the time—there are ways around doing it yourself. In fact, even if you have the time, the following option might make sense.

DON'T WANT TO SCAN?
HAVE IT DONE PROFESSIONALLY

Many photo retailers now offer a scanning service. You drop off old snapshots, 35-millimeter film, or slides and, a few days later, receive CD-ROMs filled with digital versions of those pictures. It's convenient. It's done professionally, which means you're guaranteed to have good scans. And it takes far less of your time. Prices are all over the board and depend on the retailer.

Which retailers offer this service? The smallest ones will do it best. These are camera stores and photo-processing shops that will give you the most personal, one-on-one attention. They'll hold your hand through the process, and you can be sure you'll get your originals back. When it comes to dropping off your priceless originals at a store, choose your vendor wisely.

One store that handles your scanning effectively and remarkably affordably is 30 Minute Photos Etc. in Irvine, California. It

turns printed pictures into digital photos using a high-speed, high-quality scanner at a rate of 150 snapshots per minute. The cost: just $50 for up to 1,000 different pictures. If you're in the area, you can bring your photos in for scanning, and the process will take minutes. (Imagine how long it would take to scan hundreds or thousands of photos at home!) If you're not nearby, visit the store's Web site for this service, www.shoeboxreprints.com, and arrange for insured shipping. When completed, you'll receive your originals, as well as the digital files on CD.

NO COMPUTER? NO DVD BURNER? NO PROBLEM

Want to create a photo slide show set to music on DVD but don't have a computer? Good news: A number of photo retailers are now offering this service as a complete package. You drop off the pictures you want to be included in the slide show—digital or analog—and you get back the number of DVDs you request. You'll need to prove ownership of the music you want to be included in the soundtrack because of copyright issues. Overall, if you want to create a slide show for yourself, or as a gift, but you don't own a computer or simply aren't interested in doing the work yourself, you can have it all done by someone else. Prices vary widely depending on the number of photographs and the complexity of work you want done.

Of course, because somebody is creating this, you probably won't have the same control over the finished product as you would if you were putting it together. For example, the pictures might not match the music exactly as you might want. But this is a small matter compared with the overall result: a lasting multimedia keepsake to be enjoyed with your loved ones.

EDITING AND SHARING YOUR HOME MOVIES

After photo slide show DVDs, the next logical step are movie DVDs. Here's how one family uses digital movies to help stay close to one another despite the physical distance that separates them.

When his son, Connor, was born, Anthony was an avid user of the SmugMug Web site. Aside from posting photos from his wedding, Anthony shared hundreds of pictures of his son's first two years on the site. He also used Smug-Mug to share another kind of digital memory: Frequently, he posted movies of little Connor so that his mother, Janet, who lives about 400 miles away, could watch the latest movies of her grandchild.

And she takes full advantage: Janet watches movies of her four-year-old Connor almost every day: It doesn't matter what he's doing—running around the house, saying new words, and developing new skills. "Unless you're a grandparent, you can't understand how much it means to be able to see the baby grow," Janet says. "It's the next best thing to having him around. I love the video," she exclaims. "It's so nice to watch him become more accomplished day by day."

Today, Janet watches DVDs filled with movies of her grandson's latest activities. Anthony makes the DVDs, with home movies he edits on his computer, at a rate of two or three per month. He sends them to Janet by mail. But if she doesn't feel like waiting for the discs to arrive, Janet can just log into the family SmugMug site and check out shorter version of the videos there.

But while some of movie clips make it online, all of them go onto DVDs, complete with menus designed with the same Adobe program.

CAPTURING DIGITAL HOME MOVIES

Here's Anthony's process for making great-looking movies to share with his mom on DVD and online:

In Milwaukee, Anthony captures home movies with a Sony Handycam digital camcorder that's twice as old as Connor. Which is an important point: the technology doesn't have to be brand new to capture the digital memories of your life. A four-year-old digital camcorder along with a three-year-old computer (and children of any age) will do the job just as well, if not as quickly, as brand-new gear. It records to a digital 8-millimeter tape called Digital8.

Digital camcorders are widely sold by electronics retailers online and offline. Just a few years ago, these video cameras cost as much as several thousand dollars. Today, a good one can be bought for less than $500 (see my recommendations on what to look for when shopping for a digital camcorder in chapter 2).

Anthony keeps the video camera on alert at all times: "I always keep the battery charged and keep a tape ready in there, so we can pick up the camera and start shooting," he says. This is a good way to minimize missed memories. Keep a camera and/or camcorder charged and ready to use in an easily accessible place. If you have a digital camera built into your phone, this happens automatically (please see chapter 7 for details on camera phones).

EDITING THE MOVIES

Once the videotaping ends, Anthony connects his camcorder to the computer with the firewire cable and launches a program called Adobe Premiere Elements, which he uses to capture, edit, and output his digitized movie (this program is discussed in chapter 2). This program captures—or imports—the video from the camcorder to the computer's hard drive, allowing Anthony to make changes to, or edit, the video.

His first priority, when using the program, is to cut away unneeded footage. This is similar to cropping a photograph, where the unwanted portion of the image is discarded. Anthony's final edited video only contains about 20 percent of the original footage. "You just want the highlights," he explains. And don't worry about cutting away anything that doesn't strike your fancy, because the discarded parts of the movie remain on tape—just not on the computer.

Once the video is imported, Anthony crops it and places the remaining scenes onto a timeline, which is the universal computer-based canvas for video. Just as word processors create documents, video-editing programs such as Adobe Premiere Elements create timelines. He drags and drops the scenes to the timeline and adds scene transitions such as fades or dissolves between scenes.

CREATING MOVIE DVDS

Once he completes the editing, Anthony clicks Render, which converts the pieces of video—scenes and transitions—into a single, continuous movie. Within the same program, he creates DVDs of the movies complete with menus like ones you see in Hollywood movies. Copies are created for Connor's grandparents and an original set is put away for storage.

Even on the fastest DVD burners, it takes most PCs hours to create a movie DVD. This is mostly because of the large sizes of the movie files, which have to be compressed before being burned on to a DVD. So be prepared to let your DVD burner work for hours to create your disc. You might consider letting your DVD create your first disc overnight, as it's a good idea not to work on other activities because this is a intensive process requiring most of your computer's processing resources. Once the first disc is created, additional copies go much faster because they are merely re-

productions of an original. There's no need to crunch and compress data at that point. The hard work over an extended period goes into the first copy you make. (If you make a very small editing change, however, like removing several seconds of video, the entire movie will have to be rerendered and recompressed, which will again require a lot of your computer's time and resources.)

SHARING VIDEO ONLINE

Anthony shares some of the movie clips on the Internet. However, they must be small enough for his family and friends to download quickly. "This means these particular movies are only a couple of minutes long," Anthony says, adding that the average size per movie is about 8 megabytes.

Then he opens his Web browser and surfs to SmugMug.com, where he posts the movies. "It's very helpful when you live far away from your family," he said. And, it bears repeating, this is also very helpful when you live down the block from your family. Imagine how gratifying it would be for your parents, grandparents, children, aunts, uncles, cousins, boss, colleagues, or friends from college to bring up a Web site and see a visual update on your life. It's like a multimedia holiday letter at any time of the year.

He has a Web address, provided by SmugMug, known only to people he has shared it with. Like Mark and Laurie, he could have password-protected this Web site but chose not to. The family's SmugMug site includes photographs and video of their wedding, family vacations and events, and nearly every significant moment of Connor's life, from birth to today. Both photos and movies have text captions explaining the story behind each one.

"It's such a great living memory of Connor's life," Anthony said. "For everybody. For my parents, my friends, us, and even for his children one day. It gives me a lot of pride to be able to show my son to the rest of the family. I feel a lot of pride in my family."

Who knew that technology could create such warm and happy feelings and experiences?

"I go back and run those videos every couple of days," said Connor's grandmother, Janet. "I say, 'Gee, I want to look at Connor again.' And he's there. He just stays there, and I can look at him anytime I want to."

How happy would it make *your* family members to see and hear the moments of your life anytime they want to?

HOW TO DIGITIZE THE OLDEST MOVIES

In chapter 2, I discussed how to convert analog, tape-based movies into digital video. This process—which uses a digital camcorder or a third-party digital video converter—is perfect for relatively modern analog sources such as VCRs or 8-millimeter video cameras. But what if you have old reel-to-reel films? These can be converted to DVDs for you by a variety of companies. Here are two of the most commonly used services.

YesVideo www.yesvideo.com

> YesVideo is the largest such service in the United States. It is available at the photo counter of chain stores such as Walgreens, Wal-Mart, CVS, Jewel-Osco, and Sam's Club. Bring in your tapes or films and receive DVDs with digitized video. YesVideo charges about $25 to transfer up to 2 VHS tapes to a DVD, and about $50 to put a 250-foot movie film (from a reel) on a DVD. They'll even add a musical background if you wish. YesVideo has been providing these services for many years, and you can be comfortable knowing that some of the largest companies in America stand behind its services. It takes two to three weeks to complete most orders.

Home Movie Depot www.homemoviedepot.com

> Home Movie Depot charges about $18 for a 200-foot reel movie to be transferred to DVD, or about 9 cents per foot (the standard unit of measure for pricing in this segment of the in-

dustry). You can transfer a camcorder or VHS tape to DVD for between $10 and $25 per tape, depending on whether the company is running a sale. You send in your tapes and films, and then use an online interface to create video titles and DVD menus. This gives you direct, interactive control over the finished product. The entire process can take over a month and is heavily dependent on how much time you take customizing your DVD.

CAUTION: ONLY DO WHAT'S RIGHT FOR YOU

There are a lot of options in this chapter, and that's the purpose of this book: to lay out all the great things you can do with your digital photos and home movies. But the caveat is this: take advantage of only the techniques that make sense for you. And at first, try these one at a time. Check it out. Understand what's involved. Decide if it works for you. And then either adopt the technique and use it as needed, or abandon it before trying the next one. As I said at the beginning of this book, it's easy to get overwhelmed when it comes to using new technologies. Even affordable and free Web sites like ones we have discussed can get overwhelming if you start using several new ones at once. So take it easy, go slow, and do things at your own comfortable pace. The Internet isn't going anywhere!

THE BIG PICTURE: SHARING DIGITAL MEMORIES

To sum up:

- You have a wide range of options when it comes to sharing your digital memories: online and offline, on the computer and off the computer.
- You can create CD-ROMs with digital photo albums that can be distributed to friends and family.

- A simple printed photo "catalog" with a CD-ROM containing the digital photo files is a fine, lower-tech photo-sharing method.
- There are a variety of ways to watch your pictures on television—without a computer!
- Digital picture frames are great for the nontechnical people in your life with whom you want to share photos.
- Photo-sharing Web sites are fantastic "always on" photo albums that can be accessed from around the world, on any computer with an Internet connection (and by anyone who knows your Web address and password).
- A slide show DVD makes a fantastic tribute, as well as a treasured gift, to a loved one.
- You can also edit and share your home movies. This can be done on DVD as well as online.
- Even the oldest movies can be converted to digital files and be included in your DVD projects.
- Finally, take advantage of only the sharing options that are of advantage to you. In fact, try one option at a time, and then either adopt or abandon it before moving on to the next sharing technique.

Now, let's move beyond the basics of sharing your digital pictures and movies. The following chapter looks at some of the fun, rewarding projects you can undertake with your digital images.

DIGITAL PROJECTS
*Fun, Inspiring, Heartwarming Projects for
Your Digital Photos and Videos*

Now that you know about the wide range of options you have for sharing your digital pictures and home movies with your family and friends, let's look at some of the incredibly gratifying projects you can put together with these digital raw materials. From amazing scrapbooks to professionally bound picture books, from enhancing and restoring old photos yourself to having it done professionally, from making holiday cards to making family trees enhanced by photographs, there are myriad ways to tinker with your pictures and produce end results that reward your efforts and warm your heart.

ENHANCING AND RESTORING OLD PHOTOS

Many of our oldest pictures show their age. The oldest ones are often bent, faded, cracked, folded, and dog-eared. These pictures degrade because time and oxygen combine with sometimes imperfect storage conditions. Most of us have these bedraggled photos in an album or a box, on a shelf or in a closet. But these old family pictures represent some of our most cherished possessions, and you can do some amazing things with them. You can make them look new, and you can bring pictures that are a century old into the modern digital world to create some amazing results. Consider my father's story.

MY FATHER'S WALL OF ART

Throughout this book I've shared with you the stories of how many families take advantage of digital photography. Some of the success stories have come from my own family. Here is another personal story, this one about my father, Leon. Ironically, he's not a big photographer and only recently purchased a digital camera. But while he doesn't spend a lot of time snapping pictures, he has become masterful at applying the latest digital photo restoration and enhancement techniques to his oldest family pictures.

In his home office, the wall behind my father's desk is an art tribute to his family. There are 15 framed pictures hanging on the wall behind his desk. They're photos of his parents, his grandparents, even me as a child. At first glance, these framed pictures look like just that: photographs. But if you look closely, you'll see that each photo is not a photo at all. In fact, each work is an intricate, digitally restored, enhanced, or completely altered work of art.

Some of them are dramatic improvements on the tattered originals they were scanned from. Others have completely different backgrounds than the

originals. And still others are remarkable combinations of multiple photos. One work, for example, has a picture of my wife and me, smiling together, both of us around five years old. Which is amazing, because when I met my wife, we were both in our early twenties. My dad scanned both pictures and carefully integrated them, making the finished product look like we were together when the picture was taken.

Another framed image bends reality even further. In what appears to be an original wedding-day photograph, my mom and dad, my aunt and uncle, and my wife and I all smile together for the camera. But look closer and it becomes apparent that all three women are brides. And all the men are grooms. Amazingly, my dad combined the wedding-day portraits from all three couples into a single, stunning group shot.

"I had an old family picture where most of the people looked terrible," he says. "Some had their eyes closed, others weren't looking at the camera. But I liked two of the people in that photo. So I pulled them out and made separate pictures of them. I enhanced their faces, their skin, their hair. In fact, I even changed their hairstyles." Here is an example of this process:

Here is the original picture, taken in 1964. From left to right are my grandmother, my dad, his brother, and my grandfather.

Notice the damaged area on the picture's lower right quadrant. In this photo, my dad didn't like how his mom was smiling at the camera, and he wasn't happy with his own appearance, but he very much liked his brother's and his father's portion of the photo. So he turned the original snapshot into these two photos:

Notice how the backgrounds changed. He didn't like the curtains, so they went away, replaced by designs to his liking. Also, he airbrushed my grandfather's facial features and fixed his hairstyle. Finally, note how my dad incorporated the original picture's damage into its final design on my grandfather's portrait by applying an effect to the new photo's border. Both of the restored, enhanced pictures hang as 8 × 10–inch framed portraits on my dad's wall of art. (The original scanned picture was only 3 × 5 inches!)

This might not be art to you, but to my dad, who spends days and sometimes weeks tinkering with a single image, this is as beautiful as it gets. "This is my life," he says. "It's pieces of my life. These are my antiques. They're my treasures. Many of these people are no longer with me, but here, they're with me. I can see them every day. I have my family with me." These are precisely the thoughts and feelings that digital photography is capable of creating!

"Digital photography lets you restore, personalize, and restyle your favorite photographs to your liking," says my dad, making it apparent to all that thought patterns can be passed down from father to son. "I turn pictures into works of art using common tools, common sense, and my imagination." You go, Dad!

MAKING OLD PHOTOS LOOK LIKE NEW

Recently, my dad went to work on this photo. It had become clear that he was losing the battle to keep this old snapshot of his parents from falling apart, so he decided to restore it. Here is the original that he scanned into his computer:

Using Adobe Photoshop, the powerful high-end photo manipulation software, he made it look like the photo on page 114:

As you can see, this restoration removed all cracks and tears in the photo. It also smoothed out facial features, fixed hairstyles,

and used a whole new background. There's an added depth to this version. It too hangs in a frame in my dad's office.

Here is how my dad restores and enhances old photographs:

1. **The photos are scanned.** Using a Hewlett-Packard scanner, he creates most scans at a resolution of between 600 and 1,200 dots per inch, or DPI. This is an indicator of the size of the digitized computer file. The higher the scan's DPI, the bigger the file that will be created. If you want to turn a small 4 × 6 picture into an 8 × 10 printout, you should scan at a higher resolution such as like 600 or 1,200 DPI. If you will be reprinting at the same size as the original picture, 300 DPI is enough. You don't want to go much bigger than 1,200 DPI because the files get too large and require too much of your computer's processing power. This can sometimes cause your PC to freeze up, requiring the dreaded restart—which usually results in the loss of unsaved data.

2. **Next, each picture is edited in Adobe Photoshop.** Here, the photos are corrected, which means imperfections are removed and details such as color, contrast, and brightness are adjusted. This can be done manually or automatically by the program. This is the place where changes can be made to items such as skin tone and hairstyle. There are very large books written on Adobe Photoshop. It's a very technical program with such depth that few people, even professional graphics designers, ever really take advantage of all of its capabilities. For our purposes, there are two things you should know about the program: (1) Anything you want to do with a photograph, this program can do. (2) It's probably too technical for most of us, and its consumer version, Adobe Photoshop Elements, will likely let you do everything you want with your pictures.

The most common edits you'll probably perform on a photograph are as follows: cropping (to remove unwanted elements or people and to size your pictures for your preferred print size), changing color photographs to black-and-white ones, and removing red-eye (most editing programs have a tool just for this; you select the tool, click on the red-eye, and, poof!—it's gone). Besides these common edits, which most photo-organizing programs can perform, you may want to remove blemishes from subjects' skin, change backgrounds, and adjust landscapes. Using Photoshop, you can even cut people out of photos and bring them into new pictures you compose. This is how my dad can combine multiple individuals from various shots into a single original-looking picture.

3. **When the photo is finished, it's printed.** My dad uses a $300 Epson photo printer. It's the kind of printer with eight ink cartridges. The prints are amazing: bright, sharp, rich, and detailed.

DON'T WANT TO RESTORE YOUR PHOTOS YOURSELF? BRING THEM TO THE STORE

As with many digital techniques we've already discussed, you can either restore your photos yourself or have it done professionally. A growing number of photo retailers, including every Wolf Camera and Ritz Camera store, offer photo restoration services. Many of these retailers use a company called Hollywood FotoFix to handle the image restoration. It's among the top companies doing Photoshop work for consumers in large quantities. In fact, it handles more than 100,000 photo restorations per year.

Here's how their process works:

You bring the photograph you want restored or altered to a retail location that handles this kind of work. The best way to find such a retailer is to go to www.hollywoodfotofix.com and search for your ZIP code. You'll get a list of dealers near you. At the store, you'll have your photo scanned on a professional photo scanner. This photo will be transferred to the restoration company, which will have a team of Photoshop experts work on it. In about three days, the restored photo is transmitted back to the retailer, which prints it for you.

Mark, who owns Hollywood FotoFix, says that about 60 percent of his company's work involves photos requiring major restoration—like the one of my grandparents. These pictures are torn, stained, and faded. These problems are fixed, backgrounds are changed, and in general, the photos are made to look more professional. Another 20 percent of the photographs handled by Mark's company involve removing a person from a photo. And the balance involves colorizing black-and-white photos.

If you choose to have this done at a Wolf Camera store, it will cost you about $50 per photo. This sounds like a lot at first, but when you consider the hours, days, or weeks you might spend at your computer working on each picture, it may well be worth it

for you. Remember that you'll probably get a better finished product if you have it done for you than if you try to create it yourself. For $50, you get any photo editing you want for a single photo (restoration, colorization, removing people, anything). And you get back one 8 × 10 or two 5 × 7 finished-product photos—as well as a CD-ROM with the restored digital files. Of course, if you have a stack of 20 pictures to restore, this gets prohibitively expensive for most people. But Long says he sometimes handles orders of 100 or more.

ANOTHER OPTION: SCAN YOUR PICTURE AND UPLOAD IT TO A SERVICE

There's another way to have photos restored professionally. You can use one of the online services that lets you upload your pictures, handles the restoration, and then delivers the improved prints to you. Here are two companies that offer this:

Phojoe www.Phojoe.com
Phojoe has the same price structure as Wolf Camera. You upload your image, add instructions on what you want done, and, for $50, you get a restored 8 × 10–inch image or two 5 × 7–inch shots. Phojoe will also go beyond restoration and perform specific edits such as changing the background at your request.

American Photo Restoration www.amerphotorestoration.com
For about $40, American Photo Restoration will restore your picture—which you need to scan and upload or mail directly to them—and you'll get a restored 8 × 10 print as well as the digital files on a CD.

SO MANY OPTIONS...HOW SHOULD YOU GO ABOUT TRYING TO RESTORE A PHOTO?

I would suggest the following approach: Try it yourself first. See what you can accomplish at your computer. A program such as Adobe Photoshop Elements can make a lot of improvements to your picture automatically, with the click of a button. See how things look. Then, if you're not satisfied with the outcome, try bringing the same photo in to have it done professionally. Compare the result. And since you'll also have an idea of the time it took to do it yourself, you'll be able to better judge the value of the money spent. I'd also recommend picking and choosing the photos you have restored at retail carefully for no other reason than the cost.

At $5 or $10 per picture, this would be a no-brainer for me. But I also understand that real human beings—and not just any humans but Photoshop experts!—are working on my photos one at a time, by hand, and this makes the $50 per photo understandable.

Whichever option you choose, thanks to today's digital options, you can turn old, tattered photos into new, restored images that will instantly add decades to those picture's lives—and to the time you get to enjoy them.

GOING DIGITAL WITH SCRAPBOOKING

Putting together a scrapbook with digital pictures combines many of the digital techniques we've discussed thus far. It's an exciting offline presentation that when viewed as an album involves no technology (there's no PC, no TV, no electrical components of any kind required). But the rewarding process of creating a scrapbook in today's digital world is full of technology. Here is the story of the scrapbook my wife recently put together for her father's sixtieth birthday party. (This was in addition to the DVD slide show I created. We're good kids, no?)

Lisa has been making meticulous, artistic scrapbooks for most of her life. But this scrapbook was different. It was more of a memory book, and it took full advantage of digital imaging and the Internet. Here's how we put it together:

I was assigned the task of scanning some of the oldest pictures, slides, and film negatives that my father-in-law owns. We actually had to sneak them out of his house, since the party and the scrapbook were surprises. There were about 100 amazing pictures of Lisa's dad as a young boy, and photos of his entire extended family. And because digital photographs are so versatile, we were able to use the same scans for both the DVD slide show and the scrapbook.

Once I had everything scanned, Lisa did some basic editing in iPhoto, our photo-organization program. She cropped the photos, turned some of the color shots to black-and-white, and corrected some of the pictures' color. Then she copied the edited scans—along with a number of much more current digital photos that were stored in our iPhoto program—onto a CD-ROM and took it to our corner Walgreens to make new prints of the old photos. It could have been any photo retailer discussed in chapter 4, but Walgreens happens to be the closest to our home. She popped the CD into the kiosk and ordered about 100 prints, all 4 × 6 and 5 × 7 inches. They were ready in an hour.

Over the weeks leading up to this, Lisa had been collecting "favorite memories of Ron" from his family, which is spread throughout the country. These memories arrived typed up, via e-mail, and were copied into a word processor. She used several different fonts and font colors in the printouts.

Then, in the scrapbook, each memory write-up was surrounded by photographs of Ron with the person who wrote each story. Thus, a memory book, or scrapbook, was created from a combination of the oldest photos, the newest photos, and the favorite memories of one man's life.

Ron sat on the couch tearfully viewing the scrapbook and with great happiness—and equally great detail—recalled the story behind each and every photograph in the memory book (there were a couple hundred). He

loved it. His family, who was gathered around him, loved it. And Lisa, who worked on the book for weeks, was deeply satisfied with the joy it brought to her father.

HOW TO MAKE YOUR OWN SCRAPBOOK

Technically, all you need is a scanner and a computer to put together a project like this. Collect your favorite old pictures. Scan them. Have them printed. And put them together in a scrapbook. Even a regular photo album, where you slide pictures behind protective plastic, will bring new life to old, forgotten family pictures.

And there's another advantage to doing this: in addition to the finished product photo book, you also create a set of new *digital originals* of your family's oldest pictures. This ensures that if something happens with the physical pictures, you will always have a digital version to fall back on for reprinting, which is far easier, and infinitely less painful, than losing some treasured family photos. It's yet another fantastic benefit of going digital.

Lisa, like most scrapbookers, trims each picture and positions them onto the pages manually. She secures them with photo corners or double-sided photo tape. Then she adds drawings, written descriptions, stickers, stamps, and color graphics to the page. All manually.

But two recent developments can greatly reduce the amount of time and effort you would normally put into making a scrapbook.

Supersize Printers That Make Full-Size Scrapbook Pages

Most scrapbook pages are 12 × 12 inches. Most desktop photo printers can handle a maximum paper size of 8.5 × 11 inches. Until now. Today, the leading printer manufacturers offer supersize photo printers that can handle pages as large as 13 inches wide,

which means these printers can create full-size scrapbook pages with all of the elements most scrapbookers include *printed onto the page*. The page is printed complete. Nothing needs to be added manually.

These supersize printers, such as Epson's R1800 Stylus model, are expensive, running around $500. But scrapbooking ain't cheap. The paper, the prints, and all those accessories add up. Printer manufacturers are targeting the scrapbooking community with these products, and they come with bundled scrapbook page-design software. These printers are indeed worth a look as an alternative to the manual labor of traditional scrapbooking. But for many scrapbookers, the joy is in the very process of putting together the finished product. The printouts look great, but they take all the work, which many people love, out of the process.

Software That Lays Out Your Scrapbooks Digitally

There are programs that help you lay out your scrapbook pages on your computer screen before printing them. With this software, you can substitute the scissors and glue stick with your mouse and keyboard.

Broderbund About $30 ·
www.broderbund.com

This program includes clip art, borders, corners, and pre-designed page templates for your digital pictures. You can add text captions or write out entire stories. Of course, you can create your page designs, and Broderbund says there are more than 500 free page designs available for this program at *Creating Keepsakes* magazine's Web site (www.creatingkeepsakes.com). When you're done designing your page, you can print it as an 8 × 10–inch sheet, or, if your printer can handle it, in the more traditional 12 × 12–inch format.

Hewlett-Packard's Creative Scrapbook Assistant About $30 · www.shopping.hp.com (Enter "Scrapbook" in the search field at the top of the page.)

Hewlett Packard's Creative Scrapbook Assistant uses templates and design elements like headlines, photo mattes, and caption designs for your scrapbook. Unlike traditional scrapbooks, where it's difficult to make changes once a page is put together, this digital approach to scrapbooking lets you get it perfect on the screen; position your photos, text, and effects exactly where you want them, and then, when you're completely satisfied, click Print.

Both Creating Keepsakes and Creative Scrapbook Assistant also let you package your scrapbook up as a digital file for electronic sharing, which means you can copy it onto CD or DVD and even e-mail it to friends and family.

Professionally Bound Photo Books at Remarkably Low Prices

When the three photo books that we ordered arrived in the mail, Lisa *and* I were blown away. I'm pretty difficult to impress because I deal with technology all day, every day—but these weren't high tech at all. In fact, they were as low tech as something could get. And they were beautiful. They were three incredible, professional-looking photo books from MyPublisher.com. You upload your pictures, lay them out on the pages, add text captions, pick a picture for your title page, and then select one of three options:

· A small paperback book, with 20 pages and up to 80 pictures for about $20. Additional pages cost about 50 cents. These are small memory books, perfect for your purse or pocket, to show off at a moment's notice.

· A medium-size book with a card cover, with 20 pages and up to 120 pictures for about $30. You can fit up to 120 pictures

in this book. Extra pages run about $1.50. The cover has a square cutout, through which your first picture shows. This gives the book a frame effect.

· A massive "deluxe hardcover" book that measures 16 inches by 32 inches (or a full 64 inches—or more than 4 feet) when it's open! This book rivals the quality of wedding albums, but at a tiny fraction of the cost: $60 for up to 20 pages and 120 pictures. Additional pages run about $3 each.

All three are elegant, beautiful ways to show off your pictures. The pages are glossy, and the photos look like they were printed by professionals. The large one is a coffee-table book, and the two smaller books can be put on the shelf or taken with you if your intent is to show off a bit (nothing wrong with that!).

Very similar bound books can be ordered through Apple's iPhoto software, with an almost identical process: You pick your pictures, you lay them out on the pages, your book arrives in a few days. Shutterfly.com also offers bound photo books that can be ordered on their Web site.

These professional, impressive books are a perfect way to display a category of pictures: for example, you can put a single vacation in one. Or perhaps a single subject: Create one for each of your children, or maybe your pets. For the quality, the cost is surprisingly low.

VIDEOTAPE INTERVIEWS WITH MEMBERS OF YOUR FAMILY

Remember Anthony? He's the one who edits home movies of his young son, Connor, and turns them into DVDs and online movie clips to share with his mom (see page 102). Well, Anthony also engages in a tremendous activity of another sort that will create such a priceless, irreplaceable result that you

should strongly consider doing the same thing in your own family. This is what he has been doing:

When he visits his parents in Ohio, Anthony brings along his digital video camera. He places it on a tripod, hits the Record button, and simply has a conversation with his parents, who are 81 and 76 years old. "I ask them to tell me what they remember about their lives, their family histories, and about them," Anthony says. " 'Tell me about your memories, your childhood. Tell me what you did during the war.' I want to know what they know."

He records hours of these conversations onto 8-millimeter tapes. He edits the raw video down to an hour of final footage and puts it on a DVD. Why? "So that Connor, who is four now, will be able to sit down when he's ten, when he probably won't have a grandpa around, and say, 'Oh, so this is what my grandpa was like.' "

Think about what a deeply powerful and loving gesture it is for this father to create a video of his own father so his son will be able to know him when he gets older. It reminds me of what John, the 81-year-old whose story I told in chapter 5, said: "When we're gone, this stuff gets a lot harder to find."

Accordingly, Anthony isn't letting "this stuff" go anywhere. Rather, he's recording it so that his son can always have a memory—even if it is a video memory—of the kind of person his grandfather was. This is magic.

And all it requires is a video camera and a little time with your family. You don't even have to edit the video or create DVDs with it. You can certainly put together a "final cut" DVD (I probably would), but you can also leave your conversations as raw footage. I've always thought there's a depth and an honesty to original video that's not always apparent in slick, edited final versions. Or, do like Anthony, and keep both.

Either way, this is an incredible application of digital technology that can allow for one generation to know another in a way

that could not be possible without the video footage you can create. It's easy. It's tremendously rewarding. What member of your family can you interview on video?

CREATE GREETING CARDS WITH YOUR FAVORITE DIGITAL PICTURES

My wife and I wanted to do something different for our holiday cards last year. We had been receiving a lot of the one-sided, unfolded photo cards from friends—the kind that had a photo and a small, quick greeting. It's the kind of card that feels like one single photograph, with a graphic and maybe some text thrown in. They were thoughtful, somewhat personalized (personalized by the family that sends them, but not for the recipients, as each one looks the same). So we went looking for real greeting cards to which we could add one of our favorite pictures.

These were the criteria: We wanted greeting cards that actually folded open. We wanted to be able to customize our printed message to each recipient. Finally, we send out lots of cards every year—well over a hundred of them—and we wanted all the addressing and stamping of envelopes to be done for us.

We found all of that and more at a Web site called CardStore.com. With this site, we were able to build a holiday card around one of our favorite photos of the year: a picture of our dog Cobe (who may be the most photographed dog in the world), frolicking in the snow. I cropped the picture down a bit, and then uploaded it to CardStore.

Then I picked a border from one of what must have been more than 100 options on the site. It's a "paw print" frame that wraps around our picture. On the bottom portion of the border, it said, simply, "Happy Holidays."

Inside we wrote a brief holiday message and explained to everyone that the cute animal on the front was our dog, who was enjoy-

ing his favorite time of the year. It was possible to type a custom message for each recipient, but we chose to do this by hand for some of the people on our list and had a few cards sent to us for this purpose.

Then we entered addresses for each person on our holiday card list. This was a surprisingly convenient option, as we were each able to enter our recipients' information on our own time, on different computers. Because you get a user name and password for your account, you can log in at any time, from any computer with an Internet connection, and edit the card or the recipient list. We were even able to pick the stamp that CardStore would use on our envelopes!

Here is what the final product looked like:

Our friends and family were thrilled with these cards. Most hadn't seen a card personalized this way before, and everyone was impressed with the quality. And we were happy because there was hardly any work involved! Certainly far less than handwriting every card note and envelope address.

Here's the best part: CardStore keeps a record of our mailing list. So this year, we just add a few names, remove a few, and edit some of the addresses. It will simply be a matter of selecting a good picture. (This may be the hardest step! There are far too many fantastic pictures of our two dogs.)

CardStore.com

For between about $1.30 and $3 per card (depending on the quantity; wherever the price falls in this range, your custom card will cost less than many generic cards at the drug store), plus postage, CardStore will create greeting cards with your favorite photographs on the front. The best part is, they'll do the manual labor for you: CardStore will stuff the envelopes, address them, and stamp them. All you do is enter your addresses once, and then select who gets the card. As you know, writing a hundred or more cards—not to mention addresses—takes lots of time.

You can customize the inside greeting on the card for every recipient, and add borders around your pictures as well. If you want to add a personal, handwritten message in addition to the one you typed, you can specify to have a number of the cards delivered to you first, and then you can send them when you're ready. This is a great convenience brought to you by the Internet. I'd do this even with nonpersonalized, run-of-the-mill greeting cards. But the fact that I get to put any picture I want on these cards makes it all the more rewarding.

There's an eminently helpful feature on CardStore that lets you purchase gift cards for use at a variety of major retailers to be included with your personalized cards. Think of it: Not only will they send the card but they'll also send the gift. This is fabulously useful during holiday time. You can give fantastic custom photo greeting cards and a useful (if somewhat impersonal) gift card from the comfort of your home computer.

AmericanGreetings.com

For about $3 per card, American Greetings offers a deep selection of predesigned greeting cards that can be personalized on the inside, and a small selection of photo cards that can include your pictures. They'll address your envelopes, seal 'em closed, and send your cards out for you too.

This site also delivers animated electronic greeting cards by e-mail with your unlimited-length personal message. And there is the "Create & Print" option, with which you can put together custom cards and print them at home.

PHOTOS AND FAMILY TREES

In addition to being a digital photography enthusiast, 81-year-old John is also a genealogy buff. His love for family comes from his childhood. "My father was a real visitor of family," John recalls. And throughout his boyhood, John tagged along for visits with aunts and uncles, cousins and grandparents. During these many conversations, John assembled a large box of family information.

"Then after I retired, I decided to organize it," he says. This was in the early 1990s, when the 386 DOS-based personal computer was top of the line. (Remember DOS? Long before Windows and icons, we had a black screen onto which every command had to be typed, after having been memorized.) His wife, Pat, it turns out, "dragged me kicking and screaming into the computer world," when she bought a 386 PC.

Soon after, John purchased a program called Broderbund Family Tree Maker, which is still sold today for about $50 (See www.broderbund.com). Slowly, surely, he went through his box of family information and created a lineage with the program. Then he started exchanging information with others in his family. And before he knew it, his family tree was overflowing.

"I now have 2,200 names in my family tree program," he says. "I used to spend hours and hours working on it. We all did. When someone in the fam-

ily finds something new, we send it around by e-mail so that everybody can enter it into their program."

You've already learned this about John, but it bears repeating here, in his words: "Family has always been very, very important to me. There's nothing I enjoy more than visiting relations. I always enjoyed sitting around listening to the elders of the family. Then it dawned on me that I'd better do something with these people before they all die," he explained.

So he did. He took that family tree and copied it onto a CD-ROM. Then he added a digital photo album, filled with pictures of as many members of his family as he could find. Each picture was annotated with the names of the people in it. Finally, John added his autobiography, a 244-page Microsoft Word document entitled "Dad, Why Don't You Write Some of This Stuff Down." (He wrote it for his family's eyes only. He never tried to publish this book. Never cared about that. He wrote to tell his story to his children and their children; it's the written version of what my friend Anthony is doing on video with his parents.)

So on a single CD-ROM, John now had a 2,200-person family tree, photos of hundreds of them, and a rather massive, detailed, autobiography. What did he do with the disc?

"I sent the CD-ROM to fifty-six of my relations, mostly cousins," he says.

This is just another example of the amazing things you can do with the memories of your life with a little bit of technology. Think about how it must have felt for John's cousins to receive this CD in the mail, filled with their family lineage, and hundreds of pictures. It's a priceless gift.

Think of all that John does with digital photography—he scans pictures, edits them, annotates them, creates fantastic digital photo albums on CD and distributes them to family and friends. This is all on top of his genealogy work, which is infinitely more powerful when paired with pictures of the people on his family tree. If one 81-year-old man can do all this, what can you do? The possibilities are endless.

WHAT ARE YOU PASSIONATE ABOUT?

I love taking pictures. I love sharing them with my family and close friends.

Thirty-year-old Dawn also loves taking pictures—and she takes stellar photos. She also loves sharing them. But instead of sharing them with family and friends, Dawn happens to share them with the world.

While I share my pictures in the form of prints, DVDs, and even over the Internet to my grandma's digital picture frame, I carefully protect them from the world's eyes. For example, when posting pictures online, I will only do so under the protection of a password. That's because the photos I take are for my family's enjoyment and are not meant to be seen by strangers.

Dawn's favorite subject is quite different. She loves to take pictures of the city of Chicago. If it's in Chicago, Dawn has probably taken a picture of it. She doesn't discriminate: buildings, cars, trees, parks, grass, puddles, stop signs, traffic lights, and fences are all fair game. She's more interested in photography as art. And she likes to share it with the world.

She shares it on her Web site, called Chicago Uncommon (at www.chicagouncommon.com). There are well over 1,000 pictures of Chicago on her site. They're all searchable too, so you can type in zoo and see all of Dawn's pictures from Chicago's Lincoln Park Zoo. Or you can search for any neighborhood in the city and find a photo Dawn has snapped there.

"I love photography," she says. "If I could do it full time, I would. It's a hobby for me."

She takes pictures with a high-end Canon SLR digital camera. She has five 512-megabyte memory cards, as well as several smaller 256-megabyte cards. On most of her photo shoots, which she conducts mostly on weekends, she fills up all the cards with 6-megapixel photos. That's about 3 gigabytes of pictures per shoot.

When she returns home, she transfers the pictures into her Windows-based computer and does some minor editing before posting her very favorite shots to her Web site. Most people simply view the pictures. But others

actually buy them. Dawn has prints made of the photos people order, and delivers them framed or unframed, per the customer's request. Although she never expected it, her Web site generates as many as five sales per week.

"That makes me happy," she says. "I'm sharing these pictures with people, and some of them hang them on their wall."

Dawn is a great example of somebody who has harnessed her passion for digital photography, and by combining it with another passion of hers (the city of Chicago), has created a unique Web site. John combined his passions of old photographs and family lineage for his own unique creations that he shares with his family.

If you think about what you're passionate about, it's actually quite easy to combine it with digital photography or home video and create an end result that might surprise even you. Pictures and movies are remarkable statements and records. Use them in the areas that turn you on the most.

A FINAL, PRACTICAL PROJECT: CAPTURING AND CATALOGUING THE CONTENTS OF YOUR HOME

Here's a quick activity that can save you many thousands, maybe hundreds of thousands of dollars: Go around your house with a digital camera and take pictures of your belongings in every room. Include furniture, electronics, clothing, and, critically, valuables such as jewelry and other collectables. Transfer the photos to your computer. Copy them onto a CD-ROM, and put it in a safe place. If you have a safety deposit box or a fireproof safe, put it there. If not, consider giving a copy to a family member or trusted friend who can store it for you outside your home.

This record will be incredibly helpful as a reference if you have to make an insurance claim. Chances are that during a time of stress, you won't remember every single item you owned. Insurance companies have always recommended this practice, but the

process is much faster and easier with a digital camera. You can even include a text document with the estimated monetary value of the items in your photos. Personal finance programs such as Quicken have an entire section for this kind of "belongings catalog." You can drag and drop digital pictures and add text descriptions and value estimates right into the finance program.

Computer experts always tell us to back up our hard drives. This is the offline, real-world version of a backup. It's a backup of your personal belongings so that if hardship comes, there will be no stressful and frustrating attempts at recalling everything you might have had. Your "precautionary pictures" will be waiting for you.

THE BIG PICTURE: DIGITAL PROJECTS

To sum up:

- There's a plethora of massively rewarding projects you can undertake with the photos and movies of your life.

- You can restore and enhance old photos at your computer or at a retail location near you.

- You can put together scrapbooks that combine the oldest family photos with the latest ones, creating all-encompassing memory books that are possible only with the help of digital technology.

- You can—and you should—videotape conversations with members of your family, especially older ones. How valuable will this amazing record be for future generations?

- Custom greeting cards featuring your photographs can be sent to family and friends. Better yet, have your envelope addressing, stuffing, and stamping done for you! Total cost: no more

than the price of sending generic cards and addressing and stamping them yourself.

· Combining digital pictures with family trees can make a powerful record for your family. You can integrate digital photography into just about any hobby or activity you're passionate about.

· Finally, do go around your home and photograph your possessions. Copy the pictures on a CD-ROM and put it in a safe place. You may not ever look at it again, but in the event that you need to, you'll be happy you did this.

CHAPTER 7
WHAT TO DO WITH YOUR CAMERA PHONE

If you've been through the cell phone section of your electronics store recently, you probably know that if it's a wireless phone and it's on the market today, it has a camera built in. The cameras are of varying qualities, and most are not meant to replace a dedicated camera, whether it's digital or film-based.

What do you do with that camera? Anything? If you don't, you're far from alone. The fact is that most people don't use the camera feature on their camera phone. And those who do so take advantage of only a small portion of the device's capabilities.

CAMERA PHONES AND PHOTO BLOGS

Ranjana has friends and family all over the world. She wanted a reliable and easy way to communicate with them, and, with her cell phone, she found just such a way. Only it doesn't involve using the phone to have conversations with her loved ones around the globe. Rather, Ranjana uses her phone's camera feature and snaps lots of photos—of anything and everything. She takes pictures of people, places, and things, and doesn't discriminate between the three.

Then she transfers the photos to a Web site called Fotolog.com, which is a mobile photo blog (Web log), or moblog, in technical slang. Anyone (even you) can have a Web site here. There's a free option, which allows you to post one picture per day, along with a text description of that photo. And there's a pay option—$5 per month—which raises the daily limit to six pictures per day. Fotolog has well over 1 million members.

Ranjana uses Fotolog's pay option, and for several years now, she has been posting several pictures a day. Of what? Well, of her days.

"I started doing it because I have family and friends that live all over the world, and it was a good way for them to see what I was up to," she says. "But now it has become kind of an outlet to talk about the things I want to talk about. It has offered a great deal of self-reflection."

Once she posts her pictures and the accompanying text "reflections," they can be viewed by everybody, and (this is the exciting part for most bloggers) anybody can comment on the pictures. These are not private photo albums. Rather, they are blogs, which are random postings—a sort of online diary— for the world to see and read.

"That's kind of cool that everyone sees it," Ranjana says. "At first I was weirded out by it, but now I really enjoy it. People have gotten to know my life with a strange familiarity."

Is this a good thing? Obviously, it is to some people. Of course, you can view and comment on perfect strangers' photo blogs as well. And you don't even have to have one to do so . . . just go to Fotolog.com and click around. Who knows what you might see? (Don't worry about sexually explicit materials here. There aren't any. But there is quite a lot of content intended to be viewed by adults only posted on other photo blogging sites, so use caution. More on this later in this chapter. Be assured, however, that you won't run into any surprises with the resources I provide here.)

Consider how Adam, who runs and operates the Fotolog Web site, uses his own site. You can view his photo blog at http://www.fotolog.com/cypher. If you visit, it becomes immediately clear that Adam is a big fan of food. In fact, food is all you'll find on his picture blog.

For years now, Adam has been photographing the meals that he eats and posting them on his blog. In fact, at the time of this writing, more than 3,000 meals in a row have been captured with Adam's camera phone and proudly displayed on his site.

Who would look at somebody's food? About 20,000 people per day, Adam says. His food has literally developed a following.

Ranjana's and Adam's stories illustrate the difference between photo blogs and photo sharing Web sites, which are usually password-protected and intended for family and friends, not strangers. But perhaps more apparently, they illustrate the difference between stand-alone, dedicated digital cameras and cameras that are built into wireless phones.

THE DIFFERENCE BETWEEN CAMERA PHONES AND DEDICATED DIGITAL CAMERAS

Digital cameras are for capturing events, such as birthdays and vacations and holidays. Camera phones are for things that happen every day. This is because when you wake up in the morning, you take your wallet or purse, your keys, and your cell phone. Now, your phone has a camera on it, which makes it ubiquitous in your life. You can take pictures of anything at anytime, while your stand-alone, dedicated digital camera sits on a shelf or in a drawer. You can send photos immediately from your camera phone to any e-mail address. Thus, most camera phones give us pictures as communications tools, not everlasting memories.

That said, it is very easy to make prints from the pictures your camera phone takes. From most phones, they probably won't look as good as the ones your digital camera takes, but they'll be adequate. Some newer camera phones, however, take pictures with a higher megapixel count and use lenses made by camera lens manufacturers. These are significantly more expensive (some run as high as $700), but the photo quality is excellent.

Still, as I said in chapter 2 in the section on how to pick a digital camera, picture quality is most affected by lens size. The bigger the lens, the more light it can process, and the better your picture

will be. Because of their size, camera phones have small lenses, and that is the limiting factor.

However, despite all this, camera phones are the perfect tool to capture pictures of quick moments, such as that great new thing your baby did today. And there's little you can do with digital photography that's easier than taking and sharing camera phone pictures: Press the camera button on your phone, and then take your picture by pressing another button. You can immediately see the picture you've just taken, and nearly every phone has an option on the same screen that lets you e-mail this picture immediately. Just type in the e-mail address using the phone's keypad, or pick a recipient from your phone's address book, and your photo will be delivered to the e-mail in-box of your choice. Simple, no?

Once you have the pictures, you can quickly e-mail them to your spouse or grandma and grandpa, to share instantly. Using your phone, you can also add a text message, or, with many camera phones, you can record a voice message to accompany your picture ("Look what little Johnny did today!"). This creates a true multimedia message that can arrive on your recipient's own wireless phone or via e-mail.

WHAT YOU CAN DO WITH YOUR CAMERA PHONE PICTURES

E-MAIL THEM

All camera phones can transmit pictures to any e-mail address. Just take the picture and send it off. To quickly and easily get pictures from your photos to your computer, you can e-mail pictures to yourself.

SEND THEM TO OTHER PHONES

Recently, I took this photo with my camera phone and sent it to my wife's phone. Our dogs (you've already met Cobe, on the left; Winnie is on the right) were having fun in the front seat, and I thought she'd enjoy the picture. She loved it. It arrived to her phone with a ringing alert, and she went around the office showing off her favorite canines to her colleagues. Later, Lisa

asked if I could e-mail her the picture so she could see it in a bigger size, as her phone's LCD screen—like that of most phones—is very small. I quickly obliged, pulling up the picture on my phone and e-mailing it to her. This picture made her day.

SHARE THEM ONLINE

To take advantage of any of the Web sites below, you'll need an Internet-enabled camera phone. Since it's the most popular way to share pictures you take with your camera phone, all of today's camera phones have Internet connectivity. Depending on your service providers, Internet connectivity costs between $5 and $20 per month, in addition to the cost of your regular phone service.

Also, remarkably, all of the services listed in this section are free to use. Some have enhanced pay versions, but all include a free sharing service. The reason? They all want you, your family, and your friends to order prints from the shared pictures.

Photo-Sharing Sites

Many photo-sharing sites allow for uploading the pictures straight from your wireless phone. You get an e-mail address to send your photos to using your phone, and they're automatically posted in your albums.

Many of the photo-sharing Web sites discussed in chapter 5 offer an option for you to upload pictures directly from your camera phone. In addition, here are some sites that have strong photo-sharing features.

Kodak EasyShare Gallery www.kodakgallery.com

With one of the top mainstream sharing services for mobile phones, Kodak EasyShare Gallery lets you not only upload pictures to your albums right from your phone but also *view* the photos in your galleries on your phone! You can access what Kodak calls its Mobile Service from your Internet-enabled wireless phone and see your albums formatted specifically for your phone's small screen. This is particularly useful if you want to show pictures to friends and family when you're away from your computer.

Faces.com

A free membership at Faces.com gets you 100 gigabytes of storage space and lets you upload your photos right from your phone through an e-mail address. Like most sharing sites, Faces.com handles digital photos made on your digital camera as well as those made on your cell phone. You can play slide shows of your photos as well as order print knickknacks such as mugs, shirts, and coasters.

dotPhoto.com

DotPhoto is a picture-sharing site with a unique tool that lets you create a photo slide show set to music right on its Web site. You can even add text, voice narration, and transitions between

pictures. These can be played on dotPhoto by visitors and, for $20 each, you can order DVDs with your slide show. DotPhoto can also incorporate shots you send from your mobile phone into these slide shows as well as into the photo albums you create here.

Webshots.com

Billing itself as a photo-sharing community, Webshots contains private as well public online photo albums that are open to all. As such, you can download other people's photographs—many of which are of an impressive, professional quality—for your desktop wallpaper and screensaver. Similarly, you can use these pictures on your mobile phone as background images, or even as "rings," and have different photos appear for different callers. As with the other sites, you can e-mail photos directly from your phone to your album on this site. There's a free version and a $3-per-month plan.

Photo Blogs

As I mentioned earlier, the major difference between photo-album Web sites like the ones above and photo *blogs* is privacy. Most on-line photo albums can be secured with a password and/or unique Web addresses that are not accessible to the world. Photo blogs, on the other hand, are designed to share your pictures with the world. Traditional text-only blogs exploded into mainstream popularity several years ago. Text blogs feature strangers' thoughts on anything and everything. Photo blogs feature digital pictures of anything and everything snapped by total strangers. And finally, moblogs, or mobile blogs, consist of pictures captured and uploaded from your mobile phone.

Photoblogs.org

A directory of high quality photo blogs, Photoblogs.org lists thousands of individuals' picture blogs from across the world. You can visit these sites and see how people blog with their pho-

tographs. There are some amazing pictures posted on these sites—many of them obviously taken with a digital camera as opposed to a camera phone. This is an important point: While many photo blogs use pictures that are taken with camera phones, others use digital cameras to post pictures of an impressive quality. Point your browser to Photoblogs.org to see a wide range of high-quality photography blogs.

Fotolog.com

Fotolog is one of the most popular photo blogging tools on the Internet. For free, you can create your own personal picture blog and post one photo a day. If you pay about $5 per month, you an add up to six shots per day. Most people use their camera phone to upload pictures right to this site. (You get an e-mail address to which you can send the photos from your phone, and, somewhat magically, they end up on your blog, in the correct chronological place). You can also comment on every photograph, and so can visitors. No passwords here. Photo blogs are public, open to interpretation, compliments, and, sometimes rudeness. If you want only family and friends to see your pictures, this blogging option is not for you.

Blogger.com

Owned by the Google search engine, Blogger is a free blog tool that lets you post your pictures, comment on them, and accept comments from anyone who visits your blog. You'll get your own Web address (like http://alex.blogspot.com). You can post shots from your digital camera or, using a prespecified e-mail address, you can send pictures along with a text description right from your wireless phone. In the Google tradition, Blogger is easy to use and help is plentiful.

A Word of Caution on Mobile Blogs

Be careful when you browse through various photo blogging sites, and certainly keep an eye on your children if they're examining these moblogs. The reason: Many have adult content of a sexual nature. All of the sites I've listed here are kept appropriate for all ages. But some of the most heavily visited photo blogging services feature sexually explicit content right on their home page. Use caution.

PRINT THEM

At Home

The easiest way to print your phone shots at home is to e-mail yourself the pictures you want to print at home. There are two other options to transfer the pictures from your phone to your computer for printing: a USB cable that connects the two, and the Bluetooth wireless transfer protocol. (Bluetooth wirelessly connects devices such as your computer and your phone across short distances.) But both your phone and your PC need to be Bluetooth-enabled to use the second option, which will let them talk to each other without a cable. Setting this up the first time can be a technical experience. If you're not entirely comfortable with it, just e-mail yourself the photos you want to print, touch them up on your computer, and print 'em up.

At Retail

You can also have you camera phone pictures printed at a retail location. Many phones store pictures on a memory card that can be brought in to a local retailer for printing. Other locations, such as 30 Minute Photo Etc. in California, have Bluetooth-equipped kiosks set up so that you can transfer your pictures from your phone wirelessly for printing.

Online

All the photo sharing services discussed in chapter 5 (including SmugMug, Kodak's EasyShare Gallery, Snapfish, Shutterfly, and Flikr), as well the sharing sites listed above, let you purchase prints of your camera phone pictures. As a rule of thumb, stay small. Most of today's phones take pictures with markedly lower quality and megapixel count than stand-alone digital cameras, so I recommend ordering 4 × 6–inch snapshots. Try a 5 × 7 if you want, but I wouldn't go any bigger.

THE BOTTOM LINE

The bottom line on camera phones is that one day they will take such good-looking pictures that you'll be able to use them instead of dedicated digital cameras. That day is not here yet. However, camera phones can—and, since you probably have one anyway, should—be used to complement the pictures you take with your digital camera. Remember, it's the camera you have with you, so the opportunities to take pictures and capture moments—even if they're everyday moments—goes up dramatically.

THE BIG PICTURE: CAMERA PHONES

To sum up:

· Camera phones are ubiquitous. You always have your phone with you. This means you're probably not going to take the same kinds of pictures with it as you would with your digital camera.

· Photos taken with camera phones are usually of the "slice of life" variety (such as the food you eat or the neat piece of furniture you saw at the store or "Look what the dogs did today, honey!").

- You can e-mail your camera phone photos right from your device.

- You can send them to other wireless phones.

- You can share them online in photo blogs or in private photo-sharing sites, many of which allow you to upload pictures right from your phone.

- Prints are easy: You can make them yourself, at home, or have them done for you at retail.

- Camera phones are meant not to replace your digital camera but rather to complement it by allowing you to take a different kind of photograph.

A FINAL WORD: NOW, GO DIGITAL!

Going digital will look very different for you than it will for just about anyone else. The beauty of digital photography and home movies is that there are so many possibilities. But you should take advantage of only the ones that interest you. To illustrate this point, consider the wide range of ways the members of my own family take advantage of digital technology for our pictures and our movies:

- My father-in-law, Ron, is predominantly interested in taking as many pictures as possible and sharing them, in his now well known blue binders, with family and friends. It makes him happy to give people pictures.

- As for my dad, Leon, he hardly uses his digital camera, pulling it out only when he gets tired of my constant prodding ("I don't know why you got that camera, Dad"). But he toils happily when restoring individual pictures, painstakingly perfecting each one. To me, it's painstaking. To him, it's loving time spent with the memories of his childhood.

- My wife, Lisa, loves scrapbooking. She always has, long before digital photography came around. But her last scrapbook project, for her father's birthday, took full advantage of digital imaging, combining scans of old pictures with the latest digital snapshots of family events. Interspersed among the pictures were the typed-up recollections of family members.

- And finally, for me, the creation of digital photo slide shows is the perfect marriage of digital tools: photographs, music,

DVDs, and big-screen TVs. I love good-looking prints, but nothing beats laughing and crying together with my family during a slide show I've put together.

All of this brings up the question of what parts of going digital are right for you. Is it simply making great-looking prints for photo albums and frames? That's a fantastic end result of digital photography, and if it's the only process you implement from this book, I'll happily consider my work a success!

Is it taking digital pictures and sharing them online with friends and family? Or is it editing your old family videos and watching them on DVD? Maybe for you, the process of restoring old photos makes the most sense.

The point is, it doesn't matter what you do with your digital pictures and videos, as long as you do something with them! Life's precious memories were never meant to be buried on a hard drive or in a closet. They're meant to be enjoyed, shared, and used as catalysts for conversations and recollections. You can apply only one lesson from this book or mix and match various techniques until you settle on the ones that work best for you. That's the beauty of going digital. Like my dad says, "This digital photography—it's all about choices."

Finally, remember not to overwhelm yourself. You should not try to implement all or even most of the techniques in this book immediately. As I said early on, start by trying one or two of the most interesting applications in *Going Digital* and expand from there. This is about you and your family, and your cherished priceless memories. Technology plays only a supporting role.

So go now and choose how you will take advantage of the great memories of your life.

If all the people in this book can do it, I know that you can too.

REFERENCE GUIDE
Online Resources for Going Digital

The Web sites referenced throughout this book are all listed here for your convenience. Where applicable, additional resources are listed that may be helpful to you.

ORGANIZING AND EDITING YOUR DIGITAL PHOTOS

PHOTO ORGANIZATION SOFTWARE

- **Picasa (www.Picasa.com):** A free, downloadable software for Windows PCs. Owned by Google, this is probably the best free tool available for organizing your digital photo library.

- **iPhoto (www.iphoto.com):** For Apple computer systems, iPhoto is an easy-to-use, elegant product that can be purchased as part of the iLife package for $60.

- **Kodak EasyShare Software (www.kodak.com):** A free download for PCs and Macintosh computers, this is a good organizer for your digital pictures.

- **Preclick (www.preclick.com):** A straightforward, easy-to-use free picture organizer.

- **HP Image Zone Express (www.hp.ca/portal/hho/ize/):** Free photo-organization software from Hewlett-Packard.

- **ACDSee Photo Manager (www.acdsystems.com):** A $50 photo manager for Windows, ACDSee is a full-featured organizer

with functions (such as compressed archiving of your digital pictures) that go beyond many of the free tools available.

· **iView MediaPro (www.iview-multimedia.com):** This is a high-end media organizer that handles photos, as well as movies and music—all in one program. It handles photos beautifully and is ideal for larger collections (5,000 pictures or more). It runs on Macs and Windows PCs and is available in $50 and $200 versions.

DEDICATED PHOTO-EDITING SOFTWARE

Because the photo organizers listed above offer basic photo editing such as cropping and red-eye removal, I am listing only two higher-end, more sophisticated, dedicated photo editors here:

· **Adobe PhotoShop Elements (www.adobe.com):** A $100 tool for high-end photo manipulation and editing. Probably the best higher-end consumer picture-editing software available.

· **Corel Paint Shop Pro (www.corel.com):** Available for a free trial download, this good photo editor can be purchased for $60.

FOR YOUR HOME MOVIES

MOVIE-EDITING AND DVD-CREATION SOFTWARE

· **Belkin Hi-Speed USB 2.0 DVD Creator (www.belkin.com):** This $100 all-in-one package includes cables and software for digitizing and editing your home movies and making DVDs.

· **Pinnacle Studio Plus (www.pinnaclesys.com):** A $100 package that includes a video capture card for digitizing and editing your videos.

· **Adobe Premiere Elements (www.adobe.com):** Probably the best consumer movie editor available, but no digital video converter is included.

DIGITIZING YOUR OLD HOME MOVIES

· **YesVideo (www.yesvideo.com) and Home Movie Depot (www.homemoviedepot.com):** These companies can transfer old reel-to-reel videos as well as VHS movies to DVD. Prices range from $10 to $25 per VHS tape. YesVideo charges about $50 to put 250 feet of reel-to-reel tape on a DVD, while Home Movie Depot charges about $18 for a 200-foot reel.

· **CustomFlix (www.customflix.com):** This is a useful destination if you're handing out DVDs to a lot of people at a family gathering or party. You create the DVD movie and upload it to CustomFlix, which will duplicate it for between $5 and $10 per disc, depending on quantity. A DVD takes a long time to burn on some computers (usually several hours), which means your computer might be tied up for days if you're preparing them as handouts at a party.

RESOURCES FOR SHOPPING FOR DIGITAL TECHNOLOGY

DIGITAL CAMERA REVIEW WEB SITES

· **DPReview (www.dpreview.com):** This site reviews digital cameras with mind-boggling depth. Best feature: This site's operators post pictures taken with every camera they review. A lively, informative message board also provides details.

· **Steve's DigiCams (www.steves-digicams.com):** Deep, detailed reviews with sample photos, detailed pictures of the cameras,

and a nearly identical review structure to that of DPReview.

· **Imaging Resource (www.imaging-resource.com):** Another digital camera review site that offers a remarkable level of detail. Check out the "Better Pictures" link for helpful articles on taking good photographs with your digital camera.

CONSUMER TECHNOLOGY REVIEW WEB SITES

· **CNET (www.cnet.com):** On this granddaddy of high-tech review sites, you can find product videos, along with editors' and fellow users' reviews of just about any technology on the market, from digital cameras to printers, from scanners to DVD players.

· **PC World (www.pcworld.com) and PC Magazine (www.pc mag.com):** Although their names imply reviews having to do with personal computers only, these sites cover products spanning all consumer technology categories. Many of their columnists have been in the business of reviewing products for decades—before the launch of the Internet, Microsoft Windows, and even the DOS operating system!

COMPARISON-SHOPPING WEB SITES

· **Shopping.com (www.shopping.com), Froogle (http://froogle .google.com), BizRate (www.bizrate.com), NexTag (www .nextag.com), and PriceGrabber (www.pricegrabber.com):** If you're shopping for a certain product (and it doesn't have to be technology related), these Web sites will search hundreds, maybe thousands of retailers, and they'll tell you who is selling it and for how much. This kind of free service is one of the Internet's most ideal and valuable uses.

· **ShopLocal** (www.shoplocal.com): A relatively unknown site that provides a valuable free service: Type in your ZIP code and search for a product you're interested in, and ShopLocal will scan your area's Sunday newspaper advertisements and list the retailers that carry that product. You can actually browse the Sunday circulars here!

ONLINE COUPONS

· **CoolSavings** (www.coolsavings.com), **FatWallet** (www.fatwallet.com), and **CouponMountain** (www.couponmountain.com): Before making a your purchase, visit one of these Web sites and do a quick search for coupons being offered by retailers and manufacturers. Chances are you'll find a way to save money at one of these sites.

CASH REBATE WEB SITES

· **Ebates** (www.ebates.com), **RebateNation** (www.rebatenation.com): Sign up at these sites and receive a small percentage of your purchase price back as a cash rebate. Rebates range from 2 percent to a whopping 25 percent.

POINTS FOR YOUR PURCHASES

· **MyPoints** (www.mypoints.com) and **Memolink** (www.memolink.com): These Web sites award you points for every dollar you spend. Many major retailers like Wal-Mart and Circuit City are listed. Just link to them through one of these sites, make your purchase, and get points that can be redeemed for a variety of goodies.

SHOPPING FOR COLLEGE TUITION

- **Upromise (www.upromise.com):** With an innovative approach to saving, Upromise puts a portion of your total purchase amount in a college savings plan. Register a credit card here, and you'll get a small percentage for a child's upcoming college education.

MAKING PRINTS FROM YOUR DIGITAL PHOTOS

FINDING THE PHOTO RETAILERS NEAR YOU

- **TakeGreatPictures (www.takegreatpictures.com):** Here, you can search for the closest digital photo labs, where you can take your picture files for development. More than 20,000 photo finishers are included here. Just type in your city or ZIP code and you'll get a list of stores, sorted by distance from the location you entered.

ONLINE PHOTO LABS

- **Kodak EasyShare Gallery (www.kodakgallery.com), Shutterfly (www.shutterfly.com), Winkflash (www.winkflash.com), Snapfish (www.snapfish.com), and PePhoto (www.pephoto.com):** These are the top sites for uploading your pictures and purchasing prints that are sent to your real-world mailbox. You can also display and share your photos, organized into albums, for free on most of these sites.

LARGE RETAILERS' PHOTO LABS

· **Wal-Mart (www.walmart.com), Costco (www.costco.com), Walgreens (www.walgreens.com), Target (www.target.com), and RitzPix (www.ritzpix.com):** These Web sites let you upload your photos, select a bricks-and-mortar location convenient to you, and pick up prints in person—sometimes in an hour.

INDEPENDENTLY OWNED PHOTO LABS

· **30 Minute Photos Etc. (www.30minphotos.com), Picture Perfect (www.pictureperfect-pdx.com), and Dan's Camera City (www.danscamera.com):** Smaller, independently owned photo labs like these are great for the personal attention, guidance, and hand-holding they can provide. Even though they may have only a single retail location, these stores (and many others) will mail you prints of digital snapshots you upload. If you have questions and want personal attention, consider a private shop like one of these.

TOOLS FOR SHARING YOUR DIGITAL PICTURES

DIGITAL PHOTO ALBUMS

· **Diji Album (www.xequte.com; about $40), PhotoParade Essentials (www.photoparade.com; about $25), and Photo Story (www.microsoft.com/windowsxp/using/digitalphotography/photostory/default.mspx; free):** These programs let you present your pictures as digital albums on CD-ROMs, making them excellent ways to share your photos with family and friends.

THUMBNAIL MAKERS

· **Epson Film Factory (www.epson.com; about $30), EZ Thumbnail Builder (www.esmarttools.com; free), and Easy Thumbnails (www.fookes.com/ezthumbs/; free):** These programs make it possible to print out thumbnail, or index, pages to include with CD-ROMs containing your digital images. Together, the CD and index print are a fine combination of digital and analog, letting your recipients see what's on the disc.

VIEWING YOUR PICTURES ON TV

· **SanDisk (www.sandisk.com; about $50):** This device connects to your television and accepts eight different kinds of memory cards. Of course, you can also connect many digital cameras right to your TV using a simple yellow video cable. And if you keep your photos on a laptop, you may also be able to connect *it* to your television.

DIGITAL PICTURE FRAMES

· **CEIVA Digital Photo Receiver (www.ceiva.com; about $70), AVtech Solutions Digital Picture Frame with remote (www.avtechsolutions.com/vdpf2.htm; about $160), and PhotoVu Digital Picture Frame (www.photovu.com; about $800):** These electronic photo frames display your pictures as a slide show. The CEIVA receiver connects to the Internet to download photos sent by family and friends, and the PhotoVu frame can accept pictures from any Internet connection. For most people, the CEIVA is a fine option: It's affordable, and pictures can be sent to it from anywhere in the world via an Internet connection.

PHOTO SHARING WEB SITES

· **SmugMug** (www.smugmug.com), **Flikr** (www.flikr.com), **Shutterfly** (www.shutterfly.com), **Kodak EasyShare Gallery** (www.kodakgallery.com), and **Snapfish** (www.snapfish.com): These sites may be the perfect option for quickly and easily sharing pictures with family and friends. All of them also allow visitors to order prints of various sizes.

RESTORING YOUR OLD FAMILY PHOTOS

· **Hollywood FotoFix** (www.hollywoodfotofix.com), **Phojoe** (www.phojoe.com), and **American Photo Restoration** (www.amerphotorestoration.com): These Web sites let you upload your scanned torn and tattered originals and return a restored 8 × 10 print as well as a digital version on CD. Prices range from $40 to $50 per picture—but expect these prices to fall over time.

CREATING DIGITAL SCRAPBOOK PAGES

· **Broderbund** (www.broderbund.com; about $30) and **Hewlett-Packard's Creative Scrapbook Assistant** (www.shopping.hp .com, enter "scrapbook" in the search field at the top of the page; **about $30**): With these straightforward programs, you can lay out your digital pictures on predesigned page templates; add borders, text, and effects; and print out completed, full-color scrapbook sheets. Say good-bye to scissors, glue sticks, and photo corners.

PROFESSIONALLY BOUND PHOTO BOOKS

· **MyPublisher (www.mypublisher.com), Shutterfly (www.shutter fly.com), Kodak EasyShare Gallery (www.kodakgallery.com), and RitzPix (www.ritzpix.com):** You choose the pictures. Lay them out on the pages. Select your photo album style (hardcover or softcover, for example), add text captions and a title. And in days, you get a professionally bound photo album, complete with glossy pages and your crisp, bright pictures nearly jumping off the page.

SCANNING LARGE QUANTITIES OF FAMILY PICTURES

· **Shoebox Reprints (www.shoeboxreprints.com):** At a surprisingly affordable cost of about $50 for up to 1,000 photos, you can have your family pictures scanned and delivered back to you along with a CD-ROM containing the digital files. If these pictures are your only copy, ship them carefully, and via an established, insured courier that offers tracking of packages.

MAKING GREETING CARDS WITH YOUR PICTURES

· **CardStore (www.cardstore.com), American Greetings (www.americangreetings.com), Shutterfly (www.shutterfly.com), RitzPix (www.ritzpix.com), Snapfish (www.snapfish.com), and Kodak EasyShare Gallery (www.kodakgallery.com):** Bright color greeting cards with custom messages and your photograph on the front are available at these Web sites. Many of them will even address the envelopes for you and affix the stamps. Sending out holiday cards has never been this easy—or fun!

PICTURES ON YOUR CAMERA PHONE

BLOGGING WITH YOUR CAMERA PHONE PICTURES

· **Fotolog (www.fotolog.com) and Blogger (www.blogger.com):**
These sites let you send pictures directly from your camera
phone, add a text entry, and share them with the world.
They're blogs, so there's no privacy intended here.

SHARING YOUR CAMERA PHONE PICTURES IN PRIVATE GALLERIES

· **Faces (www.faces.com), dotPhoto (www.dotphoto.com), and
Webshots (www.webshots.com):** These Web sites accept your
pictures directly from your camera phone. Your galleries are
private, however, and only people you invite for viewings can
see them.

ONLINE STORAGE FOR YOUR PHOTOS AND MOVIES

FOR SHARING, AND JUST IN CASE SOMETHING GOES WRONG WITH YOUR COMPUTER

· **EZ Archive (www.ezarchive.com):** EZArchive is an Internet
storage and organization site for your photography, home
videos, audio, and documents. You get 4.7 gigabytes of space
(about one DVD's worth) for about $30 per year. You can
view your pictures and order prints right on this site. But think
of it as a Web-based disaster recovery option—just in case.

· **Xdrive (www.xdrive.com):** Xdrive is more basic: It rents Web-
based storage space. Five gigabytes costs about $10 per

month, and you can upload your valuable photography and video. You can't display your multimedia here—but you can certainly share it with anyone who has an Internet connection. They'll have to download the files to their own hard drive before viewing them.

OFFLINE REFERENCE GUIDE
Real World, Bricks-and-Mortar Resources for Going Digital

This section provides a list of retail photo labs where you can get prints made from your digital pictures. With many of these retailers, you can upload your digital photo to their Web site, then pick up your photos in person, or simply bring your pictures in and drop them off for printing, as with film. Remember: Many of these retailers can also help you scan old photos, create CDs and DVDs filled with your pictures, and scan old photos for you, and some of them will even arrange for restoring old, battered pictures.

THE BIG BOYS: LARGE RETAILERS

Because these large retailers have hundreds, if not thousands, of locations, the best way to find the outlet closest to you is to visit their Web site and use each site's "store finder" option (each of these sites has a tool with a similar name). You can search by city or ZIP code:

- **Wal-Mart:** www.walmart.com
- **Walgreens:** www.walgreens.com
- **Costco:** www.costco.com
- **Wolf Camera:** www.wolfcamera.com
- **Ritz Camera:** www.ritzcamera.com
- **Sam's Club:** www.samsclub.com
- **Target:** www.target.com

EXPERT STORES

The following list of "expert stores" is maintained by the Photo Marketing Association, the nonprofit organization for photo retailers. These stores have earned their "expert" designation because they can make prints from digital photos and because they always have a certified photo expert on duty during business hours. You can be assured that you can go to these places to get your questions answered and have your hand held through whatever project you might be undertaking.

In the United States

Abar Imaging Center
35 Corliss St.
Providence, RI 02904-2601

Bob's Camera & Video
84 N. Main St.
Barre, VT 05641-4120

Camera Craft Shop
116 N. Main St.
Pueblo, CO 81003-3233

Camera Den
7578 Pebble Springs Ct.
Sandy, UT 84093-6161

Castle Photo
5829 Monroe St.
Sylvania, OH 43560-2275

Chris' Camera Center South
150A Laurens St. SW
Aiken, SC 29801-3848
www.chriscamera.com

Color Services
230 E. Cota St.
Santa Barbara, CA 93101-1621

Cord Camera Centers #203
223 S. Pete Ellis Dr.
Bloomington, IN 47408-6339

Cord Camera Centers #3
4545 N. High St.
Columbus, OH 43214-2637

Cord Camera Centers #23
2949 E. Main St.
Columbus, OH 43209-2614

Cord Camera Centers #28
1158 Polaris Pkwy.
Columbus, OH 43240-2024

Cord Camera Centers #21
7616 Sawmill Rd.
Dublin, OH 43016-9028

Cord Camera Centers #26
4949 Tuttle Crossing Blvd.
Dublin, OH 43016-1531

Cord Camera Centers #16
124 Granville St.
Gahanna, OH 43230-3043
www.cordcamera.com

Cord Camera Centers #27
792 Hebron Rd.
Heath, OH 43056-1356

Cord Camera Centers #45
631 E. Aurora Rd.
Macedonia, OH 44056-1805

Cord Camera Centers #46
23789 Lorain Rd.
North Olmsted, OH 44070-2224

Cord Camera Centers #40
5230 Hauserman Rd.
Parma, OH 44130-1224

Cord Camera Centers #10
6950 E. Main St.
Reynoldsburg, OH 43068-2250

Creve Coeur Camera
7 Clarkson Rd.
Ballwin, MO 63011-2215

Creve Coeur Camera
1987 Zumbehl Rd.
Saint Charles, MO 63303-2725

Dick's Camera & Video Inc.
15421 1st Ave. S.
Seattle, WA 98148-1013

Dodd Camera & Video
2077 E. 30th St.
Cleveland, OH 44115-2624

Dumminger's Photo
901 E. State St.
Fremont, OH 43420-4353

First Photo
326 E. Central Entrance
Duluth, MN 55811-5516

James Lett Company
P.O. Box 36
Lemoyne, PA 17043-0036

Karl's Cameras Inc.
P.O. Box 7819
Tyler, TX 75711-7819
www.karlscameras.com

Main Photo Service Inc.
827 S. Main St.
Santa Ana, CA 92701-5719

Midtown Photo
390 Main St.
Middletown, CT 06457-3310

Newbrough Photo
3226 Main St.
Weirton, WV 26062-4714

Ortman Photo Center
318 N. Clinton Ave.
Saint Johns, MI 48879-1570

Phopar Inc.
P.O. Box 2788
Appleton, WI 54912-2788

Photo Cullen
551 Valley Rd.
Montclair, NJ 07043-1832

Photo Express
124 S. Court St.
Circleville, OH 43113-1612

Photo Plus
Salt Pond Shopping Center
91 Point Judith Rd.
Narragansett, RI 02882-3468

Photo USA Inc.
P.O. Box 4125
Roanoke, VA 24015-0125

Pictures Plus
1685 E. Main St.
Waynesboro, PA 17268-1874

Porters Camera Store Inc.
P.O. Box 628
Cedar Falls, IA 50613-0028

Precision Camera Inc.
3810 N. Lamar Blvd.
Austin, TX 78756-4011

Reed's Camera & Video
1524 Locust St.
Walnut Creek, CA 94596-4117

Roberts Distributors
255 S. Meridian St.
Indianapolis, IN 46225-1018

San Miguel Photo Lab
P.O. Box A
Las Vegas, NM 87701-2147

Sarber's Cameras
1749 Solano Ave.
Berkeley, CA 94707-2209

Sarber's Cameras
1958 Mountain Blvd.
Oakland, CA 94611-2813

Shutterbug Camera Shops
3011 Santa Rosa Ave. # C
Santa Rosa, CA 95407-7629

TPI Custom Photo Lab Inc.
1305 S. Raccoon Rd.
Youngstown, OH 44515-4524

Wolfe's Camera & Video
P.O. Box 1437
Topeka, KS 66601-1437

In the United Kingdom
Clemens Photography
63 Fore St.
Bodmin, PL31 2JB England

Jessops Birmingham
35 Colmore Row
Birmingham, B3 2BS England

Jessops Chelmsford
97/98 High St.
Chelmsford, CM1 1DX England

Jessops Cheltenham
257 High St.
Cheltenham, GL50 3HJ England

Jessops Hanley
6 Charles St.
Hanley, ST1 3JP England

Jessops Middlesborough
7 Newport Rd.
Middlesborough, GS1 1LE England

Jessops Shrewsbury
41 Castle St.
Shrewsbury, SY1 2BW England
phone: (01743) 240225

Jessops Stratford-upon-avon
50 Sheep St.
Stratford-upon-avon, CV37 6EE England

Jessops Sutton Coldfield
The Parade Unit 216
Gracechurch Shopping Center
Sutton Coldfield, B72 1PA England

Jessops Warrington
106A Golden Square
Warrington, WA1 1QE England

Jessops Wolverhampton
4 Central Arcade
The Mander Centre
Wolverhampton, WV1 3ET England

Snappy Snaps
14 Wellfield Rd.
Cardiff, CF2 3PB Wales

In Canada

Banff Film Lab
221a Bear St.
Box 1779
Banff, AB, T1L 1B6 Canada

Winter Photographics Ltd.
P.O. Box 1057
Cochrane, AB, T4C 1B1 Canada

In Australia

Camera Action Pty Ltd.
217 Elizabeth St.
Melbourne, VIC, 3000 Australia

James Place Cameras
31 James Pl.
Adelaide, SA, 5000 Australia

Elsewhere

J.N. Harriman & Co Ltd.
9 Chacon St.
Port-of-Spain, Trinidad, and Tobago

THE TOP INDEPENDENT OUTLETS IN THE TOP U.S. MARKETS

The best way to find the small, independent photo labs nearest you is to search via the Lab Finder at www.takegreatpictures.com. This tool maintains a list of more than 20,000 photo printers around the world. Details such as the memory cards each facility accepts and each lab's largest print size are listed.

ACKNOWLEDGMENTS

In my mind, I've written these acknowledgments a thousand times. And like a child perfecting his autograph, I've been "practicing" this section long before I ever had an agent, much less a publisher. So here goes, this time for real.

When you try to write a new kind of book, a lot of people tell you, "No, it won't work." Some say yes but do nothing. I must have heard no hundreds of times. But then I came across my literary agent, Barbara Lowenstein, who said, bless her heart, yes and meant it. After I'd tried unsuccessfully for years to convince somebody that people would be interested in a book that teaches how to use technology in meaningful life-improving ways, Barbara didn't need convincing. She took this project on, shaped and molded it, and fought for it. Thank you, Barbara. I'm yours till you don't want me. And thanks to Mercedes Marx and Norman Kurz for their many efforts.

To my team at Collins: Nick Darrell, who is now pursuing a higher calling, acquired my book for HarperCollins, thank you. Thanks to Greg Chaput, and, especially to Ryu Spaeth for his many efforts with me and on *Going Digital*. And thanks to Mary Ellen O'Niell, who worked hard for this book as well. Phil Friedman and Joe Tessitore, head of the Collins division, saw the promise of *Going Digital* before nearly anyone else. Finally, thank you Katharine O'Moore-Klopf for your fine and attentive copyediting. To all of you, I thank you for believing in *Going Digital*.

As a writer, I owe nearly everything to Eric Benderoff, my first and longtime editor at the *Chicago Tribune*. Years ago, Eric allowed me, a struggling, mostly unsuccessful 24-year-old entrepreneur, to

write for one of the greatest newspapers in the land. Eric is back to his reporting roots these days, but even now he teaches me the finer points of journalism. Thank you, Eric. For everything. And then some.

Michael Lev currently edits my work at the *Chicago Tribune* and I am deeply grateful for his lessons, and for the opportunity to work with him.

At WGN Radio, I want to thank Kurt Vanderah and Tom Langmyer, who gave me an opportunity to broadcast on one of the world's most respected radio stations. I am honored to host *The Technology Tailor* show on WGN Radio. And I am especially indebted to Kurt, who teaches me "radio kindergarten," one-on-one, regularly.

A big thanks to Alan Weiss, who was there the day *The Technology Tailor* was born. Alan sees the answer before most people realize what the question is. He's a tough dude, but if you're in business, study his books. Hire him. Then listen and apply.

I'm blessed to have dear friends who have endlessly stood by me, listened, suggested, understood, and helped. I want to thank them individually: Aaron Kelley, Aaron Brown, Andy Steinhaus, Mark Sigel, Matt Kaseeska, Rich Kurtzman, Jean Schoening, Jamie Wacaser.

Now, the most important thanks:

My parents came to America as 28-year-olds, with $20 cash and zero knowledge of the English language. Watching them, I got to learn what hard work and perseverance can accomplish. Thank you, Dad, for being my role model. Thank you, Mom, for telling me, even in grade school, that I should be a writer. You were right. And thanks for being my greatest cheerleader. *Appreciation* is not a strong enough word, but they don't make words to express the gratitude I feel for everything you both have taught me. And to my Babushka Bella, who has believed and encouraged since day one, thank you. I love you all.

I am also lucky to have married into a family so warm and loving that we spend all the year's holidays together, as one family. Ron, Jan, and Keith are among my biggest supporters, and I can often be found sitting at their table enjoying some of the best food, drink, and company in Chicago. Thank you for everything.

And, most importantly, to Lisa, my wife, my best friend, and, as such, my favorite person in the world. She also happens to be my go-to editor, reading everything I write before anyone else. For this, I, along with my professional editors, am thankful. Even during the hardest times, your unconditional love and support kept me going. Thank you, Lisa, for always knowing exactly what to say. Without you, none of this happens. I love you.

INDEX